The Student's Guide to
PAINTING

The Student's Guide to
PAINTING

By
Jack Faragasso

Former Director, Instructor of the
Frank J. Reilly School of Art

North Light Publishers
Westport, Connecticut

Published by NORTH LIGHT PUBLISHERS, a division
of FLETCHER ART SERVICES, INC., 37 Franklin
Street, Westport, Conn. 06880.

Distributed to the trade by Van Nostrand Reinhold
Company, a division of Litton Educational Publishing,
Inc., 450 W. 33rd Street, New York, N.Y. 10001.

Manufactured in U.S.A.
First Printing 1979

Library of Congress Cataloging in Publication Data

Faragasso, Jack.
 The student's guide to painting.

 Bibliography: p.
 1. Painting—Technique. I. Title.
ND1500.F37 751.4'5 79-24446
ISBN 0-891-34025-4

Edited by Fritz Henning
Designed by David Robbins

Composed in 10 pt Janson and Times Roman
By Northeast Typographic Services
Printed by Lehigh Press
Bound by Economy Bookbinding

Dedicated to the memory of
Frank J. Reilly
who taught so many

Table of Contents

Acknowledgements

Today more than ever before we are influenced by the thoughts, accomplishments, and actions of the entire spectrum of mankind. However, there is, in the major realms of life always one dominate person, or school of thought, or idea, that permeates that sphere. In the realm of art, such a person was Frank J. Reilly. For me he supplied the knowledge, the program, the impetus and the inspiration to succeed. His dynamic personality and great gifts as a teacher left their imprint on many hundreds of art students. We owe him our gratitude.

Thanks must be given to the Art Students League of New York and its President, Stewart Klonis. The Art Students League allows the artist-instructor to function and develop without constraints thereby assuring total artistic expression. Thanks also to Frank C. Wright, President of the American Artists Professional League, great benefactor and supporter of Mr. Reilly and representational art. I am grateful to Fritz Henning and the editors of this book for their help and faith in this project; to the Metropolitan Museum of Art and to my students for permission to use reproductions of their paintings. Last but not least, special thanks to my wife Elizabeth Ann who typed and retyped this manuscript while offering intelligent questions and comments about content.

Author's Preface

The purpose of this book is to teach you to understand color and to use that understanding in a traditional, representational manner. The material is presented as I have been teaching the subject at the Art Students League since 1968. It is based largely on the teachings of my instructor, the late Frank J. Reilly. The principles examined are essential to anyone who aspires to be a truly fine painter. And they are applicable to the painting of all subject matter be it portrait, figure, or still life, under any lighting conditions. The examples used to illustrate the text are the subjects most commonly painted in art school. There is much within this text, however, that can benefit those who paint in other styles or hold diverse concepts in art . . . impressionism and abstraction included.

This book is the result of many years of practical experience in instructing people how to paint, many of whom never painted previously. It is presented in an orderly, factual manner — conjecture, aesthetics, theories and personal opinions are kept at a minimum. My aim is to offer as much factual material as possible and leave it up to you to apply it in your own way.

The demonstrations are in oil paint and its use is recommended for this study, however, the approach is valid for some other opaque mediums. The subjects are arranged in the order they should be learned. You should not go to advanced subjects until the initial, simpler steps are learned. I know from experience that students who did not thoroughly learn certain aspects of drawing, painting or composition suffered from this lack later on in their careers. I urge you, therefore, to do the problems in the sequence presented. And continue to practice each step until it is well understood. Much can be gained through practice. In painting our intellectual understanding usually outpaces our skill. Skill is only obtained by doing. Doing is very important.

I have to assume that the reader knows a little about drawing and composition. These subjects are much too vast to be included in a book of this scope. A lack of an ability to draw, of course, will be a great deterrent to anyone who has serious aspirations in the realm of painting. However, most of the problems in this book can be done by a person with little drawing ability. It will require a lot of care and patience. As an artist you should always be concerned with the pleasing placement of lines, values and patterns of your canvas. If you work in this manner all should be well. If you draw well so much the better. If you have experience in drawing and painting then this information can be helpful to confirm your knowledge or pinpoint your defects. The aim of the book is to help you overcome your defects, if any exist, in your understanding and use of color.

A Word About Thinking

The left side of the drawing in Figure 1 characterizes my concept of the average art student's mental process before training. It is one, big confused jumble. The art instructor's job is to unravel this puzzle for the student to help him think in clearer terms. One clear idea will lead to others. And the process continues. Soon the student's mind is conditioned to think in logical, concise terms and he can proceed on his own.

It appears we are all constantly involved with two aspects of the mind . . . the rational mind and the feeling mind. The rational, or thinking mind accumulates an immense amount of knowledge and information. Not much is known scientifically about the feeling mind except that it can be developed only by constant use. Like all other physical faculties the feeling mind is strengthened with use and withers away with disuse. Always try to be conscious of feeling. If you feel something is wrong it usually is — and if something is right you will usually feel it is so immediately. Knowledge will take us only so far in art. The rest must come from our inner feelings.

The thinking and feeling of the art student must be coupled with a proper attitude towards learning. Certainly, you will learn more and you will learn faster if you are interested in what you're doing. Strive to be enthusiastic about learning. Keep an open mind and give new ideas a chance.

These days there is much emphasis on "creativeness" and little concern of craft, although the trend is starting to change. The word "creative" is much overused and abused. As far as I am concerned man mainly reorganizes, restructures, redesigns, but does not "create" very much. Feeling and imagination play a large part in art, but with-

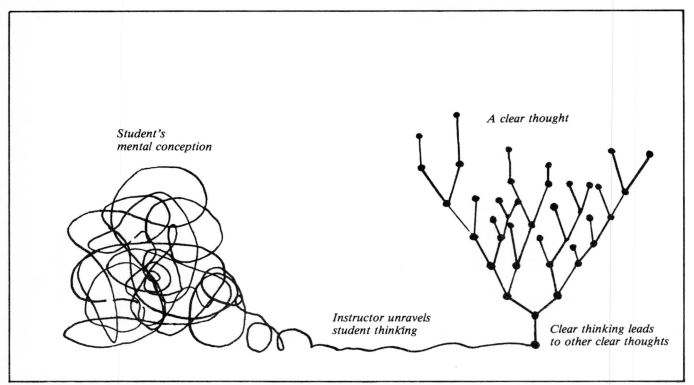

Figure 1 *A clear thought*

out hard work to develop your craft to a high degree, little of lasting value will result. Have you ever tried to reproduce a dream image or hallucination? If so, you probably found the image vanishes; in fact, it vanishes as soon as you think about it. The better you know your craft, the greater will be your ability to consciously reproduce what you wish — the better and faster you will be able to express your ideas. This is not to say the study of this book will equip you to be a dream painter; however, you should be able to interpret any visual image more effectively.

A danger exists, however, in being "overtrained" in art. An overemphasis in the craft of drawing and painting will sometimes prevent an artist from starting a painting — he wants to know how everything is going to come out before he begins. Or he will be stymmied by a fear of not being able to master a technical passage. At such times you must have faith and rely on your feelings. Remember, if the feeling faculty is not used it will vanish and a sterile, uninteresting product will result.

What about talent and genius, you ask? Talent comes in many degrees. We are all talented to a degree, some more, some less. We merely have to work hard and be interested in what we are doing to develop it. As for geniuses, I personally have never known any, although I'm told they exist and have existed somewhere, sometime. Those who have been termed geniuses by some seem to have been slaves to their talents and are erratic and one-

sided in their development. It is better a person master himself, then his art. In both life and art success comes with a lot of hard work in *the right direction* and a combination of objective vision and constant use of the feeling faculty.

If it happens you come to believe you are not making sufficient progress, analyze youself a bit. Are you enthusiastic and interested in what you're doing? Are you following instructions properly? Do you practice enough? Remember no one can give you skill, it can come only by your own efforts. If you want enough the skill you seek, it will come.

Do not become depressed if you feel others are progressing faster than you. I have seen hundreds of students come and go over the years at the Art Students League and at the Frank Reilly School of Art, and I have drawn definite conclusions about how artists develop. Some students advance rapidly in their first few months of training only to slow down to a snail's pace later on. Others learn slowly at first and then later speed up remarkably. At the end of three or four years of training most students are quite equal in knowledge and skill. I have also observed that those who were termed "geniuses" by their fellow students 25 or 30 years ago are no better artists now than those who evolved slowly over the years. There being so much to learn and we all learn at a different pace.

One last word. You may carry within you a number of

negative factors that can be detrimental to your progress. These factors are likely to stem from early childhood influences of parents, relatives, friends, or teachers. Rightly or wrongly they have to do with your evaluation of yourself and your ability. Coupled with these factors may be other misgivings because of nationality, religion, race, social status or economic background. All of these may be difficult to overcome but at the risk of sounding simplistic I say they can all be regarded as meaningless if *you* decide they are.

You will never know what you can accomplish unless you try. Our greatest satisfaction in life is our attempt to fulfill our true potential.

Thoughts on Seeing

If a group of individuals look at the same object it is likely each one of the group will see it differently. How Sherlock Holmes would look at a person is likely to be vastly different than you would see that person. To look is one thing, to see is quite another. To look at something means the use of the sense of sight; to see something im- plies a more acute perception, an understanding of what you are looking at. To be an artist we must learn to see as an artist.

Most of our inadequacy in seeing can be overcome with training. The beginner merely *looks* at the model or subject, but with guidance he can start to analyze what he is looking at and, in time, he learns to *see*.

The problems of seeing are multiple and complex. There are as many reasons for this as there are people involved. Each of us looks at things according to our unique perception of life. We see what we want to see based on mental, emotional, physical, even metaphysical influences. In addition, what we see is transformed and often confused by the nature of the atmosphere in which we view it.

We should learn that nothing in life or art is absolute. Everything changes. Whenever and whatever we paint must be a judgement, a composite, an abstraction of what is before us. We must select, emphasize or underplay what we feel will make an effective painting. To accomplish this we need to have command of the technical skills and, most of all, to be able to *see* what we are looking at.

CHAPTER 1
Color

The purpose of this chapter is to familiarize you with the basics of color in painting. It will describe and show you how to obtain the three major components of color: hue, value and chroma. You will be shown how to see color accurately and to mix any color you want. These principles will be an invaluable aid in color composition and allow you to paint whatever you wish.

Unfortunately, there are no magic color formulas that will enable you to paint beautiful pictures. There are a number of books available on color that have fascinating theories. These theories may work well for the artists who formulated them but you may find that they do not work for you. If you try them you'll probably find yourself rejecting certain colors or combinations of colors, altering others, or adding new ones that appeal to you. Eventually your own color sense will assert itself, and the color theories will languish in disuse.

Color, like everything else in life, goes in and out of fashion. What seems to be a beautiful color scheme today may look ugly or garish tomorrow. It can also work in reverse. For this reason it is not a good idea to permanently base your color concepts on what is highly regarded today, no matter how famous the formulator may be.

When you become knowledgeable of painting, you will find that you will be able to "date" almost any painting by its color composition. This proves that there is always a trend or "general look" to the paintings at any given period. And, as surely as the sun rises, that trend will, in time, move on to something else. Often there is an attempt to repeat a certain era of color, composition, and drawing styles. Perhaps we need a respite from always going on to something new. The popular artists then search out old reproductions of paintings of the "in-style" and borrow from them. They come close at times, but the newer work is always different. Art seems never to return to exactly what it was. It is as if color flows from some unknown, unseen realm into this physical world; we perceive it and use it. It is ever changing and ever moving, intricately woven into our visual world. It is hard to believe that man, over such a long period of time, has done so much with such limited color — and there is no end in sight.

The best way to start the study of color is to analyze it objectively as it pertains to painting and let our knowledge and feelings guide us in its use. We need not concern ourselves with spectrascopes, rainbows or prisms to learn about color for use in painting. Such things are best left to the physicist. We use and paint with the colors whose properties are readily apparent. Some pigments come out of the earth and some are manufactured in laboratories. They are all mixed with a binder and put into tubes and jars for our use. These colors have many differences between them and interact quite differently than the colors revealed to us by light. It is paint we work with, it is the color property of paints we must learn.

Seeing Color

One of the major reasons people have trouble in handling color is that they are trying to copy the color they think they see before them. This usually results in failure. Color changes according to what is next to it. For instance, you may be trying to paint a subtle violet tint that is next to a green. If you place a neutralized grey next to the green the grey will appear reddish violet. This is because our mind's eye seeks the compliment of any color. Only after you fail to obtain the red violet by using the grey alone should you add a touch of reddish violet to the grey. If that does not work then use a purer violet. This principle should be applied to all complimentary arrangements.

Another visual color phenomena has to do with time. The longer you look into a color the lighter and stronger it will appear. This is one of the reasons a painting sometimes gets out of balance and loses its unity. More of this later.

A third color consideration has to do with a technical problem. When you put light on an object it appears lighter in value. Value means the degree of lightness or darkness. The student perceives the color, say red, in sunlight, and paints the red color as strong as he can. He fails. This is because he has not obtained the correct value. White has to be added to the red from the tube to bring it

up in value, but when he does this it turns pink. It is not the red that he sees and is trying to match. You really cannot paint a strong red color in sunlight. See Figure 7. The point here is that our paints do not approach the brilliance of nature's light. Paintings of naturalistic scenes are made to appear successful by the *proper ratio* of paint values to nature values. This subject is extensively covered in Chapters 7 and 8.

Hue, Value, Chroma

Color is identified by a name such as red, yellow, blue, etc. The color's name is called its *hue*.

The second aspect of a color is its value. This is harder to understand and is seldom properly perceived by the student. As already stated, the value of a color is its degree of lightness or darkness. If we make a scale using white paint at one end and black paint at the other end we could produce many intermediate greys by the admixture of the black and white paint. Generally such a scale is divided into light, middle and dark values.

Every color has a value. It can be measured as being no lighter or darker than a dab of a particular grey paint next to it. Although any hue can have full range of values, in general terms we think of yellow as a light value, cadmium green as a middle value and ultramarine blue as a dark value, etc. A simple way to judge the value of a color is explained in Figure 2.

Values are not to be regarded casually. They are essential for any good painting whether in the overall design or in producing the illusion of form. In general artists who desire a maximum of form use little color, concentrating mainly on control of values. Painters whose chief concern is color often sacrifice much form. To paint a picture that has both good values and beautiful color is a difficult task.

Figure 2

Judging the value of a color

Make three smears of a middle grey as shown in the top row. Each smear should be exactly the same value. Mix three different values of green and with your finger or on the tip of a palette knife, plop a spot of each green on each of the greys. Be careful not to mix the color with the grey.

Now, by squinting your eyes, see which green visually blends with the grey. When the grey and the green blend together they are of the same value. Here the first green is much lighter than the grey and it appears to "pop out." The green on the grey in the middle is of the same value. The green on the last smear is too dark and appears to "punch a hole" in the grey.

To confirm your value, reverse the process . . .

Make three smears of the green paint of exactly the same value as is in the bottom row. Place a little dab of light grey paint on one of them, a middle grey on the next and a dark grey on the last smear. Squint your eyes; where the grey visually blends together with the green it is the same value; in this case obviously it is the second.

The same method is used to judge values of different colors. The last two swatches show a small amount of red paint over a green swatch and a small amount of this same green paint over the red. By squinting you can see they are about the same value.

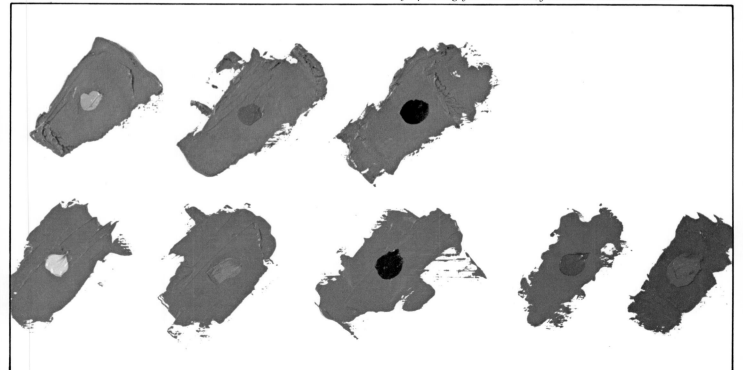

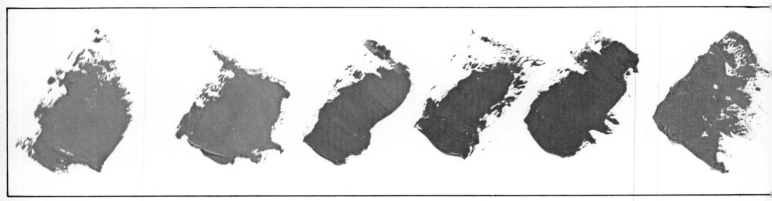

Figure 3
A neutral grey is on the left, the strongest chroma red oil paint from the tube is on the right — the intermixing of the two produces different chromatic steps, weak chromas on the left, strong chromas on the right.

The third aspect of color is chroma. Few beginning students perceive it accurately. Chroma can be explained as the degree color departs from neutrality. For instance, if we place neutral grey paint on the palette and mix in a small dab of red paint of the same value we will be making a weak chroma red. If we add more red to it we make a middle chroma red. In oil paint, cadmium red light or cadmium scarlet from the tube are the strongest chroma available for opaque painting. Therefore, the inter-mixing of the red and the grey produces many different steps of chromas. A few are shown in Figure 3.

The weak and middle chromas may not seem like red to you. Manufacturers of paint, clothing and cosmetics, to name a few, give these chromas interesting and exotic names, like Burnt Rose or Puritan Brown. Nevertheless, they are all different chromas of red.

There are many other terms people apply to color such as intensity, luminosity, saturation, refractions, etc. Such terms will be avoided in this book. They are not needed, because understanding color merely involves knowing what hue, value and chroma are.

It is comforting to know that a bit of paint of a certain color can only do just so many things. Once you have identified its hue then you should know that it can only get lighter or darker in value, or weaker or stronger in chroma — or change its hue as it goes into a prismatic progression. See Figure 4.

It will be a good idea for you to duplicate Figure 4 using a number of different colors. It is a fascinating exercise which will increase your command of color.

It's not as simple as it first seems. For example if we lighten a color, say red, with white, it will turn a cooler hue, namely red purple. This is because white is cool, almost bluish. To keep the hue red as you add white, you have to add a bit of yellow or yellow-orange to the upper values. In this way the hue will stay red. To bring the red down in value you have to first make a mixture of burnt

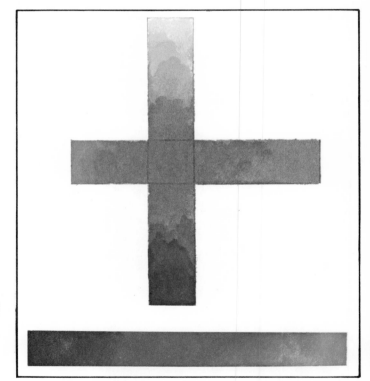

Figure 4
The swatch of color that is being altered is in the square in the center of the cross. It is lightened with white to make it lighter, darkened with Burnt Umber to make it darker, neutralized with a grey of the same value to make it weaker in chroma, (to the left), and increased in chroma by the addition of a strong yellow-red of the same value, to the right. The bottom section shows a prismatic progression of a hue, in this case violet to yellow green, or if you wish, yellow-green to violet.

14

umber and alizarian crimson. Add this mixture to the red and it will remain red as it gets darker in value. You can't use Alizarin Crimson by itself as it is really red purple at a dark value, and will, therefore change the red at the lower values towards red purple. If you wish to weaken the chroma of a color without changing its value you must proceed as follows: Mix a grey to the same value as the color under consideration (see Figure 2) and then add it to the color. Figure No. 5 shows this procedure.

Chapter 10 will explain how you can mix tonal graduations of any color, in any lighting condition.

Figure 5
The mixture of white, (a) with red, (b) produces a light red, (c). To weaken this red in chroma we must make a grey, (e) of the same value as (c) and add it to the light red (c). Beginners should always follow this procedure when weakening a hue in chroma.

The Color Wheel

The color wheel (Figure 6) shows the ten basic hues fully graded in nine equal steps of value. The way to raise and lower values is as follows, but keep in mind there are many other ways to do this. Follow each step and create your own wheel:

Yellow is Cadmium Yellow Light from the tube at its uppermost value. It is brought down in value by first making a mixture of Burnt and Raw Umber and adding this to the yellow. If you use just Raw Umber it will turn the yellow to a greenish hue and if you use just Burnt Umber it will make it too warm.
Orange is really yellow-red. Cadmium Orange is the paint name. Add white to bring it up in value and Burnt Umber to bring it down in value.
Cadmium Red Light is brought up in value with white and a tinge of yellow. To bring it down in value add a mixture of Burnt Umber and Alizarin Crimson (using merely Alizarin Crimson would alter red to red-purple.) to the Cadmium Red Light.
Red-purple is Alizarin Crimson; just add white to bring it up in value.
Purple-blue is Ultramarine Blue; add white to bring it up in value.
Blue-green is Viridian; add white to bring it up.
Blue is made by mixing Ultramarine Blue and Viridian together — at a midway point the hue becomes blue. Add white to bring it up in value.
The three remaining hues are difficult as there are many different hues involved and many ways to accomplish our purpose. Brand names are tricky — what is called violet may be a reddish-purple. What is called a green may be a blue-green or a yellow-green. To make the purple we can use a Cobalt Violet. Adding white to it brings it up in value, but, we will have to make a mixture of Alizarin Crimson and Ultramarine Blue to lower it in value. Green yellow is Permanent Green Light. Add white to it with a tinge of yellow to bring it up in value — add Lamp Black and Burnt Umber in various degrees to bring it down in value. You have to keep adjusting so as not to turn the green hue too warm or too cool at the lower values.

Green can be made many ways — Cadmium Green Deep is a good starting point. Add white to the green to bring it up in value; if it turns bluish, add yellow. To bring it down in value add Lamp Black or Burnt Umber and Viridian. One should keep in mind when making a color wheel that the hues should appear equidistant from each other and that the value steps within the hue not only should be equal in graduation, but equal to all the other value gradations in the other hues.

Creating this color wheel can be an invaluable exercise in learning how to use color. It teaches you the basic hues and their complements — the colors directly opposite each other on the wheel. It teaches you to raise and lower the values of any hue while maintaining its identity. You can readily see how you may harmonize the same values of different hues. There is no rule on how many value steps one need make. You may make as many as you see fit, but if you make more than nine steps the differences may be too subtle to see.

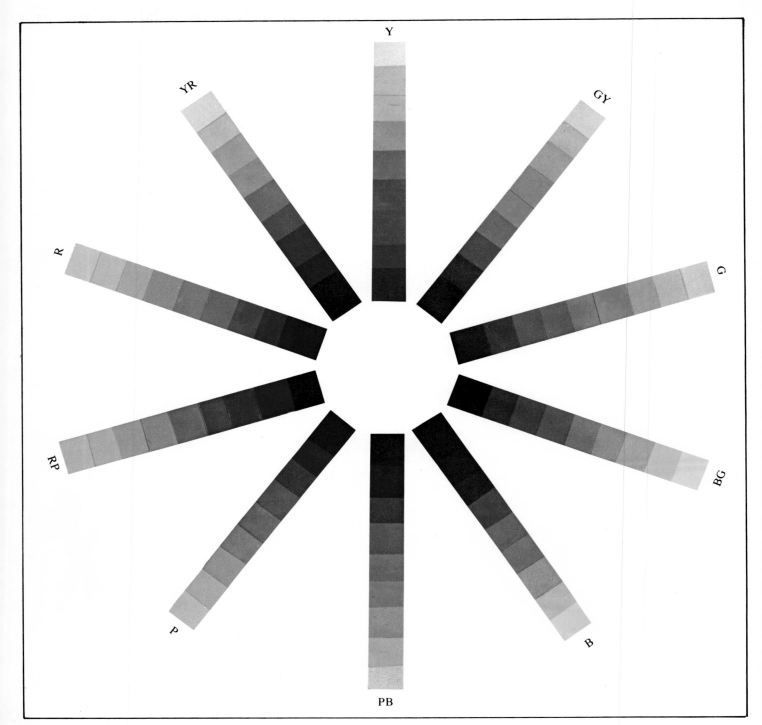

Figure 6
The color wheel, 10 hues of 9 equidistant values, the values of
any hue match the values of all the other hues. The compliments
are directly opposite each other.

The Hues in Sunlight

Figure 7 is an exercise to be done with the hues of the color wheel. It shows the ten basic hues in sunlight and shade. First, paint the ten hues on a nonabsorbant surface as shown. Outline them with a white border and surround it with a light green color to represent grass. When complete wait for a sunny day and place it on the ground in the sunlight. Then cast a shadow over it. Observe the hues in light and shade and make a painting of them as in Figure 7. I warn you that you won't be able to paint them the way they appear to your eye. If you paint them the way they appear you will lose their values and the result won't seem sunny. When you take the study indoors and adjust the values you will have a sunny look; however, the colors may appear washed out. You must compromise a bit with the values to avoid the washed-out appearance. Keep in mind the lights are warm and the shadows cool outdoors.

To obtain proper sunlight values in a scientific manner refer to the sunlight scale in Chapter 8.

The Neutral Grey

I have often been asked by my students, "Isn't it possible to neutralize any color with its complement?" My answer is both yes and no. Sometimes a complementary color may work, other times a warm, cool, or neutral grey works better. Theoretically one can neutralize any color with its complement, but, when it comes to doing it with paint it becomes difficult and in some instances impossible with the end result of mixing usually becoming a non-descript brown. What works in the realm of light does not work in the physical realm of paint. Another consideration may be the economic factor. Why use an expensive Cadmium Red to weaken a color when an ordinary inexpensive mixture of black and white paint will do the same thing?

As repeatedly stressed in this text the *value* of a color is of the utmost importance. Since the hues are of all different values it stands to reason that when complementary colors are intermixed for the purpose of neutralization you will lose the *value* of your hue. You are also likely to lose the identity of your hue — that is, the hue will become warmer or cooler.

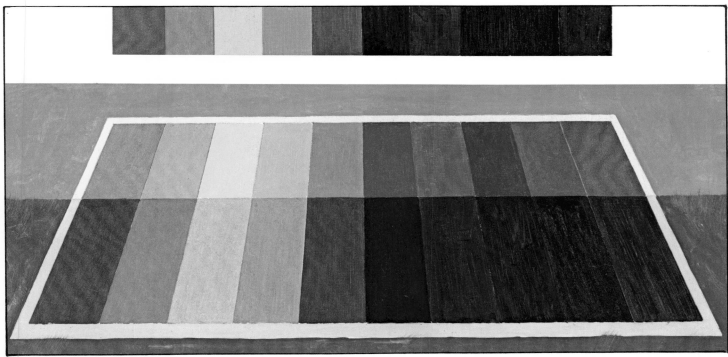

Figure 7
The upper portion of the chart shows the 10 basic hues. The lower portion shows these hues, plus white, and a green representing grass in sunlight and shade. You must add Cadmium Yellow Medium to the white in the light and a bit of Ultramarine Blue to the white to represent white in the shadow. Generally in sunlight you add yellows to the lights and cool blues such as Ultramarine to the shadows. To achieve an even greater feeling of sunlight raise the values of the hues in the light. However, the hues will lose much chroma and look washed out to most people. Compromise is often involved here.

Figure 8
Gradation from a cool to a warm grey.

It is, therefore, easier to neutralize a hue with a neutral grey of the same value to the chroma you wish. The hue and value then can be accurately maintained.

Mixing Titanium White and Ivory Black together produces a cool grey, that is, one with a bluish cast. If we mix Titanium White and Raw Umber we will obtain a warm grey — a grey inclining to the yellow-red side of the spectrum. By mixing these two greys together we can obtain varying degrees of warmth and coolness. A neutral grey is somewhere between the warm and cool grey.

Figure 8 shows the cool grey on the left and the warm grey on the right. The two greys in between are made from the intermixture of these warm and cool greys. The second grey from the right is still too warm. The second grey from the left is, however, visually a neutral grey.

When such a neutral grey is juxtaposed with, or placed on top of a hue, it will take on the complementary color of that hue. For instance, if a neutral grey were placed on top of or next to a field of orange color the grey would look blue at a distance. If it were placed on top of a swatch of green the grey would appear slightly red-violet.

In my opinion, these optically created complementary hues are more subtle, delicate, and beautiful than those

I'll not pass judgement on the merits of the two teaching systems, but, it seems easier to have a class where everyone uses the same number of values and the students and instructor speak and understand a common language.

The nine value system is a good choice. If there are more than nine values the differences between them become so slight they are hard to "read." If there are less than nine values they jump too much and it's difficult to model forms properly. Carefully study Figure 9.

The Making of the Neutral Greys

Now, with the number of values decided, you can proceed with the actual making of the neutral greys. Remember, grade them from light to dark in *equidistant steps*. The lightest grey will be next to white. The darkest grey will be next to black. I say equidistant steps because the degree of visual difference between white and the light grey next to it must be the same degree of visual difference between that light grey and the darker grey next to it — and so on down the line to black. If you squint hard at the nine greys between white and black there should appear to be a smooth progression of values. If you see a gap or a

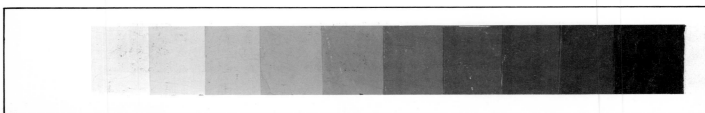

Figure 9
A scale of 9 equidistant greys between white and black

which are directly stated. Before you put down a stroke of color you *think* you see, make sure it isn't a grey between some strong colors making it appear as a complementary hue. Rubens frquently made use of this principle by making his halftones grey, surrounded by warm shadows and lowlights. At a distance the grey appears to be blue or blue-violet.

If you desire complete control over your palette then you'll need a gradation of neutral greys ranging from very light to very dark. However, you should first decide on how many value steps you want. The great American artist and teacher, Frank V. Dumond, had his students make value gradations, but he would never tell them how many gradations to make. Dumond felt the students wouldn't think things out for themselves if he defined the number of values, as a result every one of his students had a different value scale. Some had only five values, others had thirty-five.

Frank Reilly, who studied with Mr. Dumond, insisted on nine value steps. He claimed that he worked for years evolving a nine value system only to find out later that Albert Munsell had long before established a nine value system of hue, value and chroma notation. (Actually, some French painters as early as 1648 used nine values of flesh tones as a standard.)

jump between two values you know that there is something wrong and an adjustment is in order. The light values should not appear to be crowded on one end nor the dark values crowded at the other end of the progression.

To make the neutral greys you will need both warm and cool greys. You may start first by making nine cool greys of equidistant steps between white and black. The easiest way to do this is with Titanium White and Ivory Black. Next, you will need nine exactly matching values of warm greys. These you will make with Titanium White and Raw Umber. Now add an amount of the warm grey to the cool grey of the same value until a visually neutral grey is obtained as shown in Figure 8. Rely on your judgement. Do this with all your nine values. Remember, it is essential your warm and cool greys are of the exact same value and that you only mix a warm or cool grey of the *same* value with one another. *All your nine values should have the same visual degree of neutrality when you are finished.*

It is difficult to give an accurate recipe for these mixtures since every paint manufacturer makes paints a little different from the next. Also, they vary their own pigments, binders, fillers and oils from time to time. For this reason you may get into difficulty neutralizing your greys. It may be necessary to add a bit of Cadmium Yellow-Orange to one value or a green, a blue, or burnt umber to

18

some of the lower values to achieve your goal. It was because of this complex, time consuming task that a well known paint manufacturer discontinued making neutral greys.

Testing the Neutral Grey

The true test of a neutral grey is that it should not alter the hue towards the warm or cool side of the spectrum. See Figure 10. If we have a strong red of a certain value and wish to neutralize it — that is weaken its chroma without changing its value — we must first mix a grey of the same value as the red. We then add this grey to the red. The grey will not alter the value of the red, but it will reduce its chroma, that is, the red will look duller than it was originally. However, if the red appears cooler, towards the red-violet, to your eye then the grey is too cool. If the red appears warmer, towards the yellow-red side of the spectrum, then the grey is too warm. The true neutral grey will reduce the chroma of the hue without shifting the hue towards the cool or warm side of the spectrum.

Once you grasp this idea you should mix large quantities of neutral greys and put them in studio sized tubes. They will last you at least through two years of student work. Some of the lesser used values will last many years. It sounds like a lot of work, but the whole job can be done in one day. It will save you much time and paint in the long run, and you can be assured of absolute control over your color mixtures in whatever you intend to paint.

A few final words on mixing greys. If you are a beginner you will find it more difficult to make neutralized greys than in creating the nine equidistant steps of values. For this reason, I allow my beginning students to make the greys merely out of Titanium White and Ivory Black. This produces greys with a slightly bluish cast. However, since they will be used mainly to produce flesh tones indoors by mixing them with yellow-red paint, the complement of blue, these greys work quite well. If you paint mainly landscapes and other outdoor effects, you will find that greys made with Lamp Black and white work best with your colors. Lamp Black is bluer than Ivory Black and so the colors produced with the greys will be quite consistent with the effects caused by the light coming from the sky.

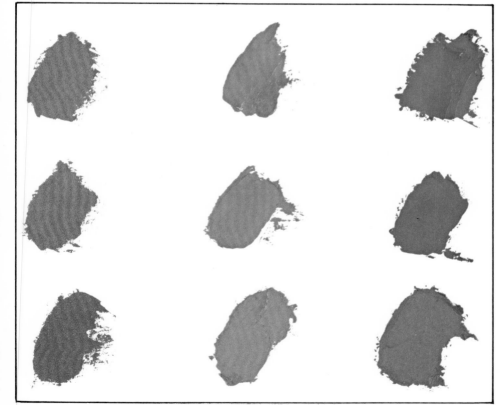

Left side, in a downward row,
three dabs of the same red paint.

Center, in a downward row,
a cool grey *the same value as the red.*
a neutral grey *the same value as the red.*
a warm grey *the same value as the red.*

red mixed with the cool grey *making a coolish red.*

Right side, in a downward row,
red mixed with the neutral grey *making a neutralized red inclining neither towards the warm nor cool side of the spectrum*
red mixed with the warm grey *making a warmish red.*

Figure 10
The illustration shows how to test a grey for its neutrality. It also shows how a cool, a neutral, and a warm grey alters a given hue.

Warm and Cool Colors

Colors are often referred to as warm and cool. In the older books on color a line was drawn across the color wheel usually through the yellow-red and blue hues — all the colors on one side were called warm and all the colors on the other side of the line were called cool. Today we know that this is a hard distinction to make.

We now tend to think of color more in terms of psychology and relativeness. Of course, this is far from absolute as not everyone is conditioned psychologically the same; blue may look distant and cool to one person and warm and friendly to another. However there is a warm and cool aspect of almost every color. Usually this effect depends upon what color or colors are placed next to it. We think of Cadmium Yellow as a light warm yellow but Lemon Yellow and Zinc Yellow are cool yellows. Actually the cool yellows are different hues. They have a tinge of green and therefore could be called yellow-green-yellow. It is a lot easier to call the color cool or warm. Cadmium Red Light is a warm red but Grumbacher Red, which is almost the same value, is a cool red. So is Harrison Red. Greens which are cool can be made warm by the addition of yellow, orange or almost any of the earth colors.

Generally we may say that warm colors contain yellows, yellow reds and reds, while cool colors contain blues and violets. If you cool or warm a color too much you are in danger of losing the hue. The shift to coolness or warmth of a hue should be very slight for the maximum effect of beauty. Practice making a hue warm and cool in the following manner. Take Cadmium Yellow Light, Cadmium Orange and Permanent Green Light and arrange as shown in Figure 11. Add white to the Permanent Green Light and to the orange to bring them up to approximately the same value as the yellow. Now add a little of the green-yellow to the yellow. Keep adding small amounts of the green-yellow. Do the same with the orange. There will be a point on both the left and the right of the yellow where it ceases to be yellow. To the left it becomes yellow-orange, to the right it becomes yellow-green. It will, however, be a "cool" yellow on the right and a "warm" yellow on the left. No one can say with any certainty where the exact dividing line should be. Do this

exercise several times with several hues to develop your awareness of the warmth and coolness of colors.

Partial List of Warm and Cool Colors

Here is a small list of what are commonly referred to as warm and cool colors:

WARM	COOL
Cadmium Yellow Light	*Thalo Blue*
Cadmium Yellow Medium	*Manganese Blue*
Cadmium Yellow Deep	*Cerulean Blue*
Cadmium Yellow Orange	*Ultramarine Blue*
Cadmium Orange	*Cobalt Blue*
Cadmium Red Light	*Veridian*
Cadmium Scarlet	*Alizarin Crimson*
Yellow Ochre	*Permanent Green Deep*
Raw Sienna	*Thalo Green*
Burnt Sienna	*Oxide of Chromium*
Burnt Umber	*Terre Verte*
Cadmium Red Medium	*Indian Red*
Terra Rosa	*Cobalt Violet*
Light Red	
Venetian Red	

Manganese Blue is the warmest of the blues. Ultramarine blue is the coolest, as it goes towards purple. Cobalt blue tends toward the cooler Ultramarine. Mars Violet is a warm violet. Lamp black is a cool black. Thalo Yellow-Green is a warmish green.

Keep in mind that many of these warm colors can turn cool with the addition of white. Also, that after you bring the hue up or down in value and you wish to weaken its chroma you must add a neutral grey of the *same* value to it. You can do this also by adding the complement of the hue of the same value (see color wheel, Figure 6) but this is more complicated and often does not produce better results. You can see the vast possibilities of color mixing with this method. Exercises like these will help you understand, perceive and obtain the colors you want. These rudiments should be mastered if you hope to do any serious work in the field of painting. How you *feel* about color is what will transform it into a work of art.

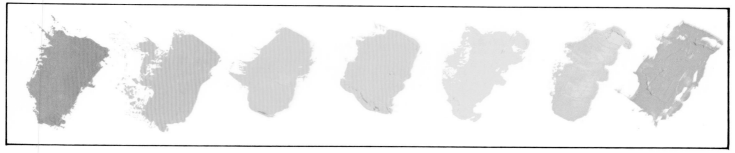

Figure 11 The warm and cool aspect of a hue.
Almost any hue can be made warmer or cooler. Simply add the hues to the left or to the right of the hue on the color wheel. First, however, it is advisable to make all the hues approximately the same value, for it is usually best to change only one thing at a time. Here we have a yellow hue in the center. The yellow is made warmer by the addition of yellow-red on the left and cooler by the addition of green-yellow on the right. Hues can also be made cooler by the addition of white, black, grey, complements, or by surrounding them with warm colors when they are weak in chroma. A glaze of a warm or cool color can also be used to alter the hue.

Figure 12
These four charts show distinctions between hue, value and chroma. Keep going over them until you are sure you thoroughly understand just what hue, value and chroma are.

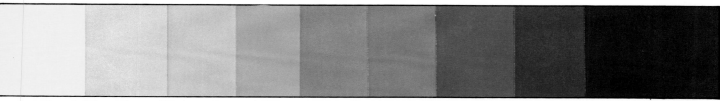

a. examples of different hues, different values and different chromas.

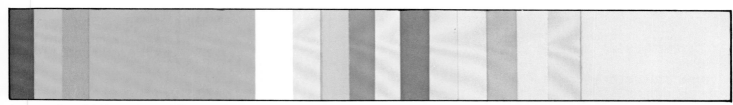

b. examples of different hues, different values but all of the same chroma.

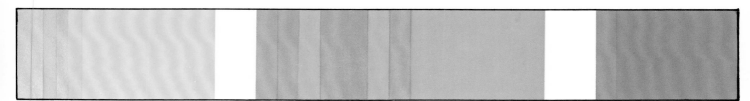

c. examples of different hues, different chromas but all of the same value.

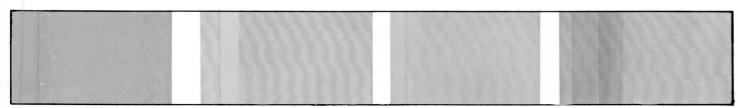

d. examples of different hues, same chroma, same value.

CHAPTER 2
Concerning Colored Light Sources

When the color of the light source changes many other changes take place both on the subject and on the background. A light source that is colored can come from nature, such as the sun, the moon, various colored skylights, or it can be from man-made sources such as incandescent light or strong red, blue, and green theatre lights, etc.

A colored light source mainly affects the light side of the model or subject. The shadow side of the model is affected but little and produces the illusion of its complementary color on the cast shadow. The cast shadow is the complement of the source of the light plus the color of the background. For instance, a yellow light on a white object against a white background turns the object and the background yellow in the light areas but the cast shadow appears to be purple-blue, the complement of yellow. This same principle applies to all the hues. Consult your color wheel for complementary colors. Suppose we put a white object against a purple-blue background with the same yellow light on it. You will find that the yellow will neutralize the purple-blue background but the cast shadow will remain purple-blue. In another instance we will try this same yellow light on a white object in front of a green background. The yellow light adds itself to the green background so it becomes green-yellow. The cast shadow now becomes blue-green-blue. As stated before, the cast shadow is the complementary of the light source plus the color of the background. Figure 13 shows how to arrive at this.

Please keep in mind that these are ideal conditions. Seldom are they found this way in nature. There can be other sources of light that reflect into the shadow and cast shadows altering their hues. The chroma of the cast shadow will be approximately half the strength of the chroma of the light source. It is curious that when the cast shadow goes away from you it appears slightly stronger in chroma than when it is closer to you. In painting first try to achieve the illusion of the complement with a grey. If this doesn't work then add the complementary color to the grey.

In our age we have many forms of colored lights affronting us everywhere; whenever these colored light sources are exceptionally bright they will produce effects on everything near them. A most interesting effect is when someone or something is in front of a very bright colored light. Actually, this happens quite frequently in nature outdoors. The sky's color can wrap around the branches, leaves and twigs of a tree. If the twigs are very thin the sky's color, whatever it is, will completely overcome their local color.

Painters did not seem to pay much attention to these effects in earlier times even though some artists must have known about them. DaVinci even wrote about the wrap-around phenomenon in his treatise on painting. Certainly, the Impressionists pushed complementary color effects to their limits, and the art conscious public began to appreciate their efforts once the " brown sauce" paintings that preceded them became discredited. Also, American illustrators were very big on complementary color harmonies in the early 1900's and then many dropped them, moving on to invent their own color compositions largely independent of nature. Keep in mind what you are looking at in nature and be aware of what nature can be made to look like in painting. They are two different things.

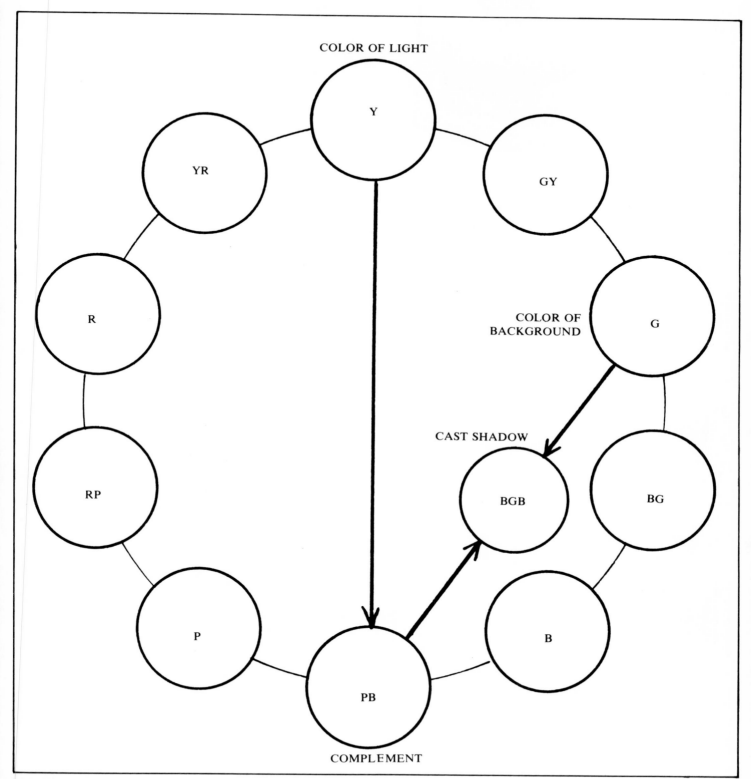

COLOR OF LIGHT

COLOR OF BACKGROUND

CAST SHADOW

COMPLEMENT

Figure 13
The cast shadow caused by a colored light will be the complement of that color providing the background is white. To arrive at the color of a cast shadow on a colored background follow this diagram.

CHAPTER 3
Value-Patterns

There are two major problems we encounter in the early stages of learning to paint. These problems also plague the more advanced students and quite a few professionals as well. The first is we do not perceive that each object, when averaged out, has a value-pattern all its own. It is usually different from the value patterns of other objects in the picture.

The second problem grows out of the first. Missing the object's overall value-pattern, the artist models each form in the picture with an equal degree of light and shade. The result is a jumble . . . a catalog of isolated objects bearing no relationship to each other within the painting. The beauty of a unifying light falling on everything within the picture is entirely lost.

To avoid these pitfalls, to become a better painter, and to help you in designing a picture, you should adopt a definite approach in looking at subject matter. Try to forget the details and the light and shade of the form; simply look at its big outside shape and reduce it to a general, allover value and pattern.

It's important to learn how to do this. Some people find it helpful to squint or blur their eyes. When you see things out of focus you lose the sharp lines and details. What definition remains is caused mainly by the separation of values. This is what you want to see.

The spaces *between* the forms are also to be taken into consideration. These negative patterns should be similarly reduced to an average value. Don't think of individual objects. Think of groups of forms and overall pattern. If an object has the same value as the negative shape behind

Figure 14
The value-pattern concept applied to portrait and landscape.

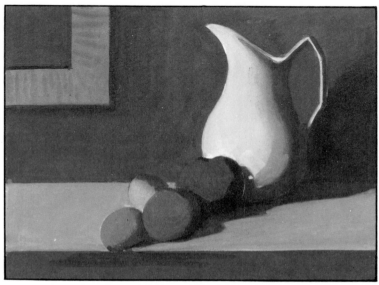

Figure 15
Examples of value-pattern studies. These should be of the simplest shapes and values. They can be varied ad infinitum.

it, then the object and the negative shape should be considered as one value-pattern. You would make a great step forward in your perception if when you see a scene you *did not* say to yourself, "this is a person, this is an apple, this is a vase." Instead, if you look and say, "this is an overall middle value against a dark value; this is a pale yellow against a dark red." When you truly relate to a scene in this manner you will have made real visual progress.

Figures 14 and 15 are simple examples to explain this way of seeing. Study them.

Set yourself up similar studies. Eliminate details and light and shade for these problems. Keep the scene in a front lighting condition. Start with simple objects at first, for example, a white pitcher against a dark and middle background. Now change your dark and middle background and make another painting. The objects you use at this stage should be white, middle, or dark, and simple in shape. Once you grasp this idea, add smaller objects of different value-patterns, such as an apple and an orange. The third stage is to add a shadow shape on each object and a cast shadow if it has one. Brush the shadow and light together slightly but leave the outside edges alone for now. These studies are invaluable. The same rules apply to painting a portrait, a figure or a landscape.

We have now discussed color and color in relation to values. Once you grasp the idea of value patterns you should find it easy to get the correct color to match them, and you should match your color to your value. You are now left with three problems: how to get the proper shadow values; how to make the color go around the form properly (this is explained in "The Mixing of Tones"), and how to brush your edges (covered in Chapter 9).

CHAPTER 4
Forms and Planes

Form

A thorough knowledge of form and planes is essential to anyone who desires to be a good artist. I maintain that the difference between a first rate painter and a mediocre one is the former always paints in the planes on the forms precisely where they should be. The weaker artist does not have the perception to do this. Forgeries, copies and imitations usually fall short of fine works of art for the same reason.

Forms come in many sizes and shapes. An egg is a form, as is a cube, a cone, a shoe or a table. Almost everything is a composite of basic forms such as a cube, cone, sphere, cylinder or pyramid. In short, a form is a solid shape that has bulk and volume. Since forms are usually opaque they have light and shade on them. They can, of course, touch, overlap and rest on each other. See Figure 16.

It's important to think of the figure in terms of its major forms. The big forms of the body are the head, the torso, the leg and the arm. Examples of the next smaller forms are the rib cage, the breasts and the buttocks. The smaller forms are the ball of the nose, the nipples of the breast, and knee cap, to mention a few.

Do not underestimate the value of the study of forms. In representational painting the large forms must be understood and maintained. And the smaller forms have to be subordinated to the larger.

Planes

A plane, in relation to form, is as a facet on a diamond. Another way of thinking about a plane is this: slice a piece off a peeled hard boiled egg with a sharp knife. The slice creates two planes — one on the egg, the other on the piece. See Figure 17.

Basically, a plane is a flattened area of a form. It can be the top, side, bottom or front of a form. Planes can make a tangent with other planes or be atop other planes. Planes can be vertical or horizontal, repeat themselves and vary in width.

The human being is an extremely complicated arrangement of forms and planes. For example, the nose is a form. The flat plane of the nasal bone wedges into it. The bottom of the ball of the nose flattens into bottom planes, both front bottom and side bottom. In painting the nose the right application of paint exactly where the plane is and fusing it to the proper degree with its adjacent planes is extremely difficult, and it requires a lot of skill and *perception*.

Once you are familiar with what forms are, you should start adding planes to them. The next step should be to make simple studies from a cast in charcoal or charcoal pencil, concentrating on the largest planes. After you become familiar with the big basic planes on the cast, you'll be able to work from the live model with more understanding.

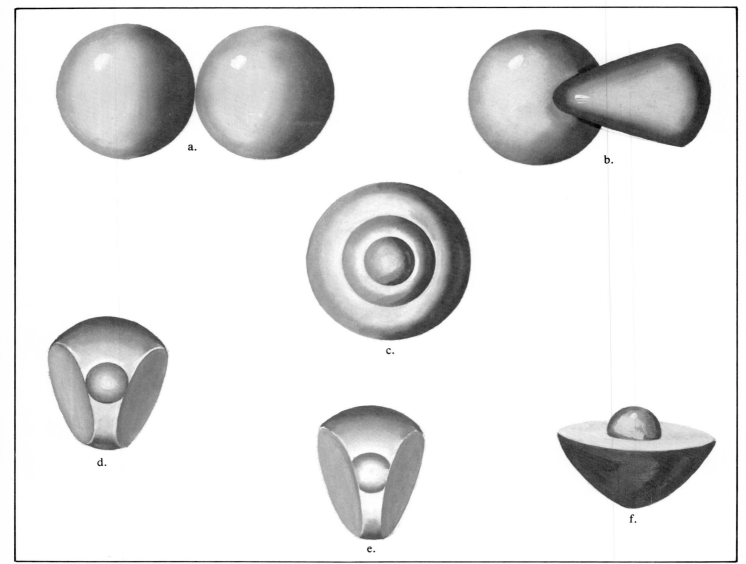

Figure 16
Some examples of forms, *a. A form touching another form.*
b. A form overlapping another form.
c. Forms on top of other forms.
d. A small rounded form making tangent with two planes.
e. A small rounded form being overlapped by two planes.
f. A form on top of a plane of a form.

Figure 17
Three examples of planes on forms. There will be planes on everything you paint in nature except perfect spheres. You can even paint a sphere by dividing it up into many little planes. The values shown are not necessarily true. They are for descriptive purposes only.

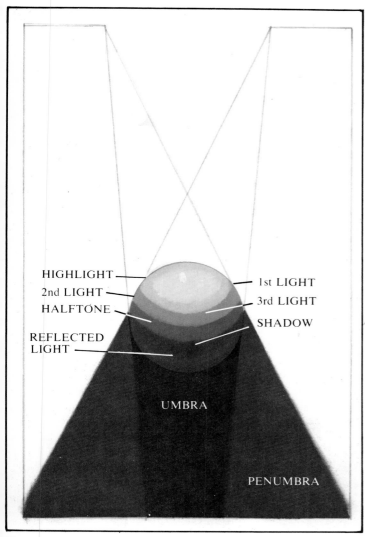

HIGHLIGHT

2nd LIGHT

HALFTONE

REFLECTED
LIGHT

1st LIGHT

3rd LIGHT

SHADOW

UMBRA

PENUMBRA

Figure 18

A sphere in simple light and shade. The shadow is always at right angles to the source of light. In front of the shadow is the halftone. In front of the halftone are at least three distinguishable values of light. The highlight is at the cresting of the area of lightest light.

The shadow cast by the sphere is of two major parts, the umbra and penumbra. The umbra is the darkest part of the shadow. The penumbra is lighter than the umbra, it is a "half shadow". It is soft edged that becomes even softer as it recedes from the object's edges. The umbra also becomes soft edged as it recedes from the object and eventually merges into the penumbra. Not shown is the darkest dark, commonly called the accent. The accent is only where no light can enter, such as where the object touches the surface. Since we are looking down on the sphere we cannot see this aspect of it. However, it would be readily discernible in a side view.

The Crest Light

One of the most common errors in painting is the rendering of the forms in the light so they appear too flat. This happens because the painter does not see any discernible planes. Indeed, many forms, such as spheres, have no discernible planes.

What produces the plane in this case is the light increasing in intensity as it approaches the cresting of the form. We will call this light the Crest Light. The crest light is always soft on all sides. It blends imperceptibly into the surrounding areas because it does not exist on a flat surface. Do not confuse the crest light with a highlight. The highlight, if any, is smaller than the crest light and usually is within the center of it. Parts of the highlight may blend into the crest light but usually there is one part of the highlight which stays quite distinct. Highlights are commonly found on *corners and ridges* of forms. Therefore, if a form crests to such a degree as to form a corner rather than a rounded surface, the light atop that corner could be called a highlight.

The black and white illustrations in Figure 19 are examples of crest lights. The top row shows *cross-sections* of each of the forms. The second row is a *top view* of these same forms with light and shade on them. Notice the variations of the width of these lights and how they relate to the cross-sections above them. Try to visualize the cross-section of any form you paint in order to get a better idea of this crest lighting and its position. The third row shows how this crest light is formed.

a) Simple light and shadow on flat surfaces
b) A halftone made by making an additional plane
c) The bending of the light areas which produces a gradation of the lights and a crest light.

On the bottom row, (d) left, we see a triangular form. Notice how the width of the crest light tapers with the tapering of the form. This principal applies to all forms.

To the right, (e), we see how the crest light follows the direction of the forms. This principle is most commonly applied in the figure to the arms and legs. Notice how the crest light on the bottom form tapers to a point and disappears as it merges into a flat surface.

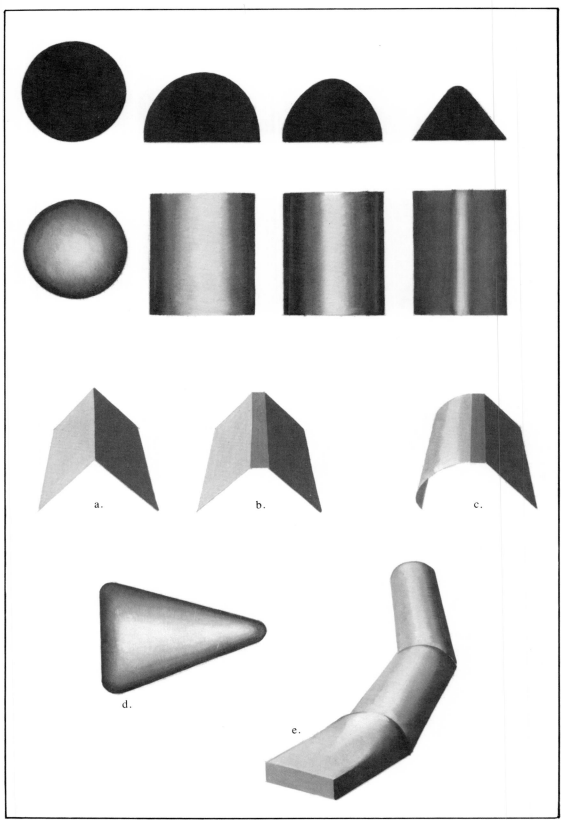

Figure 19
The nature of the "Crest Light." See text for explanation.

CHAPTER 5
Shadows and
Their Values

Let's now look into the nature of shadows and their values to try to understand them a bit more. Simply stated, that side of a form which is not receiving direct illumination is called its shadow side. When observed under one light source, forms that have light and shade have basically three big planes, a light plane, a halftone plane and a shadow plane. There are other planes within these such as a top plane and a bottom plane, but we will not go into this now.

Shadows would appear black if it were not for the general atmosphere or secondary light sources falling on them. The atmosphere consists of air, dust, moisture, gases and some forms of electrical phenomena. On the moon or in outer space where there is no air, shadows are black. Only reflected or secondary light sources would illuminate them. On Mars, where the atmosphere is thinner than the earth's, shadows would be darker than those on earth but lighter than those on the moon. On earth, our primary concern, the atmosphere and light from the sky reflect light into the shadow plane making it a value far lighter than black.

There are other factors which enter into the shadow value, such as the distance the subject is from your eye, the distance the subject is from the background, the reflective power of the background and the texture of both the subject and the background. A nap texture such as velvet reflects little light and therefore will appear quite dark. A white broadcloth, on the other hand, reflects a great deal of light into a shadow area. All of these factors should be considered before you make a decision as to what value your shadow will be.

It is quite logical that the lighter the value pattern of a form the lighter its shadow value will be, the darker the value pattern the darker its shadow, providing of course, it is in the same surroundings. All shadows are not the same

value. Since white will have the lightest shadow value and black the darkest shadow value it follows that all in-between values will have relative shadow values.

There is an important rule concerning light and shade that you should remember. With few exceptions, anything within the light side of a form is lighter than anything within the shadow side of that form. Areas that appear light within the shadow seem that way because they are surrounded by a large amount of darkness — the same as dark areas surrounded by light appear darker. Areas of light within the shadow should be painted darker than you think they are. Areas of darkness in the light should be painted lighter than they appear. In this way the illusion of light on form is maintained. If you paint things the way you think you see them you'll find what you have painted looks flat.

All of this is to teach you to see nature in its relativeness. Stick to these rules for your studies and I'm sure you'll find them helpful throughout your painting career. However, remember your feeling faculty. You may find, for instance, when painting a portrait of a woman that you want to paint the shadows lighter and more colorful than the rule indicates. Or, another time, you may gain a more dramatic effect by lowering the shadow value. Special effects in picture design may require altering values and colors, but such changes should be based on knowledge and not caprice.

Study the value diagrams in Figure No. 20. They show white, black and a middle value in light and shadow in common lighting situations. Place a piece of clear acetate over the page and match your paint with these values.

If you are interested in a more scientific method for ascertaining values you'll find the answers in the following chapter.

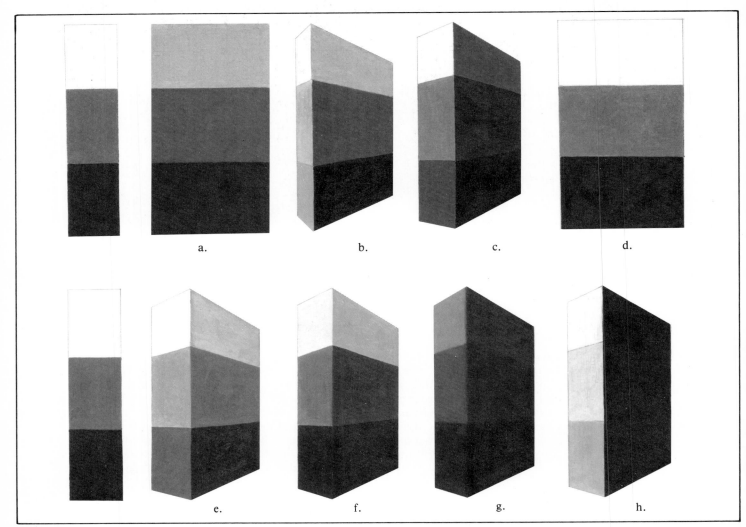

Figure 20
A white, a middle and a black value in light and shadow shown in
different lighting situations.
 a. In back lighting
 b. In rim lighting
 c. In form lighting
 d. In front light
 e. In sunlight
 f. In grey daylight
 g. In moonlight
 h. In a spotlight
These lighting situations are fully explained in the next chapter,
"Light and Shade"

CHAPTER 6
Light and Shade

The world we see is revealed to us by light, either natural or artificial. Examples of natural light are sunlight, moonlight, and skylight. Examples of artificial light sources are incandescent bulbs, kerosene lamps, candles, etc.

When painting a picture we are faced with a number of constant, inter-relating lighting considerations, including the source of the light, the angle of the light to the object, the textures, values, and planes involved, and the object's position in the scene as well as its distance from both your eye and from the background. All of these elements of light and shade must be examined.

Obviously, the painting of form in light and shade depends primarily on using the correct values. The degree of lightness or darkness of an object is what gives it dimension. You can err considerably on the hue and chroma of form and it will not be too noticeable — indeed there may be times you'll change the hue and chroma purposely. However, mistakes of value will be noticed immediately. Great painters of every age have usually been exceptionally gifted in the handling of values. Rembrandt and Vermeer are outstanding examples of artists who mastered values. The same is true of John Singer Sargent. Don't despair, and think you must be in such august company to control values successfully. Many lesser talents can manage values beautifully. There is much technical knowledge concerning values available that can be of immense help to you. Much of it is supplied in this book. Whether or not you take advantage of this knowledge is up to you.

In order to understand what is happening when an object is seen in light and shade you must concern yourself with several factors. The thing that first impresses you is probably the object's color. This should not concern you at all at this point. What is important now is the type of and position of the source of light, the objects "home" value and texture and its surroundings.

All the values can be determined in an underpainting by constant comparison with each other. However, when first painting from life the student is usually confused by all the colors he thinks he sees. He is not aware of the *value* of the colors. These values vary immensely from outdoors to indoors — from sunlight to candlelight, and from the innumerable different positions of the light to the object and of the angle of the eye to the object. A small amount of thinking will convince anyone that the range of nature's lighting is thousands of times greater than our paint range. How is it then that we achieve "naturalistic" effects on the canvas? How do we get things to look "right"? The answer lies in ratios. When we achieve a certain value ratio in paint relative to nature then our painting looks "normal". Fortunately, all these ratios have been figured out for you a long time ago by Frank J. Reilly, Harold Speed, myself and others. If you follow these examples of ratios, scales, and black and white studies you will be well prepared to start painting.

The Value Ruler

The first thing you must determine is the "home" value of any object or scene before you. Since this book focuses mainly on the painting of the human form with indoor lighting we'll confine ourselves to this aspect of the subject. To make a judgement of these values you will need a *value ruler*. With it you will measure values in much the way you measure with an ordinary ruler.

A value ruler can be made out of any material and be of almost any size. However, a small one, thirteen or fourteen inches long, thin, and about 1½ or 2 inches wide will be quite sufficient. The material you use must be non-absorbent, such as acetate or a primed illustration board. If you use illustration board coat it with several coats of a polymer gesso first. The surface of the board should be made smooth and white. This strip is then divided into eleven equal spaces, white being at the extreme left and black at the extreme right. There will be nine equidistant greys between the white and black. The lightest grey is to the right of white and the darkest grey is left of black.

Figure 21 The four basic lighting conditions.
 a. *Front light, where the light source is directly in front of the subject.*
 b. *Form light, where the light source is usually at a 45° angle to the subject. The shadow portion can occupy anywhere from 1/2 to 7/8ths of the area.*
 c. *Rim light, most of the subject is in shadow. There is a brilliant thin rim of light on the subject.*
 d. *Back light, all of the subject or object is in shadow, the light source behind it.*

It is wise to mix all these grey value steps on the palette first. When you are certain that the values are all equidistant from one another, place them on newsprint or paper towels, if you are working in oil, and let most of the oil soak out.

By "equidistant" I mean that the visual degree of difference between white and the ninth value is the same degree of visual difference between the ninth value and the eighth value and so forth down the scale.

These values, including white and black, are now painted on to your surface, whether it be cardboard or acetate. Take care that they *do not* smudge into one another. Try to get as flat a painted surface as you can as ridges will interfere with the judgements of values. After the paint is thoroughly dry, cut a notch at the edge of each of the values.

Using the Value Ruler

The value ruler is used to judge the "home" value of any object or material. This is done best in a studio with light that comes in from the north side or outdoors on an overcast day. Such light will be the most constant and glare free.

Lay your value ruler on top of the object you are studying. Now look at the values on your ruler. You will see that some of them are lighter than the object it's resting on and some of them are darker. Light values seem to "jump out" whereas a darker value will "punch a hole" in another value. Wherever the value on your ruler appears to be no lighter or no darker than the object it is on, then you have found the "home" value.

The "home" value will change in different lighting situations. For instance, in sunlight it is one value and in moonlight it will be an entirely different value. Through the use of scales the complete value range, that is the values of the lights, halftones, and shadows of the object in any lighting situation, can be ascertained. These scales can be used whether you are painting from nature or if you are painting from photographs. You can also readily transpose one set of values from one lighting situation into another set of values for another lighting situation. For instance, if you are painting a nude in a studio with a north skylight and wish to make it appear as if it were in sunlight you could easily do so.

The Four Basic Lighting Conditions

There are innumerable lighting conditions; however, they can all be reduced to four. All other conditions are simply combinations of the four.

These four basic conditions are front lighting, form lighting, rim lighting and back lighting. See Figure 21.

Let's now discuss the qualities and characteristics of each of these lighting conditions before we go to the actual scales.

Front Lighting

Front lighting, is, as its name implies where the light is directly in front of the object. There are *no* shadows in front light; however, the edges of the form are painted in darker than the mass. When the darker edges are brushed together with the mass we produce the illusion of form.

Objects in front lighting show their colors at their purest. There are no glaring highlights to bounce all over and no dark shadows cutting into the light areas. Front lighting is usually used by artists when they want to place emphasis on pattern and color. It is also often used by portrait artists when painting women. One must be careful in portraiture, however, as front light has a tendency to make people appear fatter than they are. This must be compensated for by drawing the subjects thinner and longer than they actually are. Almost everyone thinks they look better this way anyhow.

Form Lighting

Form lighting reveals the form of an object most readily. The form lighting condition can vary considerably but generally it is taken to mean that the object is anywhere from one-half to three-quarters in the light — the rest in shadow.

Form lighting tends to emphasize the character of a person and is therefore used by many portrait painters where this effect is desired. Although form lighting has a slight tendency to bleach out some of the color in the highest lights it is the most easily "readable" of all lighting conditions. For this reason models are posed most frequently in this lighting condition in my classes. Form lighting shows the three dimensions best.

Rim Lighting

Rim lighting is the most dramatic and brilliant of all the lighting conditions. It is commonly used by illustrators to have their main figures stand out from the background or to strongly emphasize important areas. In painting rim lighting is used mainly in sunlight or moonlight effects.

Local hues and values of an object bleach out almost completely and tend to lose their identity under rim light. Under this condition a red, a yellow, and a blue in the light would scarcely be distinguishable from each other. Black, a middle value and white would be almost the same value on the light side. However, in the shadow side of rim lighting, much can be done in terms of the modeling of values and the manipulating of delicate hues.

Back Lighting

The light source is completely behind the subject in the back lighting. What we have, in effect, is "shadow lighting"; that is, everything is in shadow on the subject. In back lighting, indoors, the less the light the less the detail. Generally there is less detail in back lighting. Modeling form in back light is accomplished by the very subtle use of values. If one goes too high in value the lighting effect will be lost.

After you are familiar with the basic lighting conditions and their characteristics you are ready to study the value scales that apply to them.

Each of the four basic lighting conditions have a "normal" condition, a stronger than normal lighting condition, and a weaker than normal lighting condition. When a series of pictures are painted with these values and placed side by side they will all look relative to each other. This would prove the efficacy of the values.

The Value Scales

Let us now see how the value scales work. We'll start with the front lighting condition first. In all cases the top row of numbers in the following charts represent the values in nature. The top row always goes from white to black, represented by the numerals 10 for white and 0 for black. Now, if you wish to paint an object illuminated by front lighting, you will find the paint values will remain almost the same. What happens is that black, (0), now becomes the first value and therefore pushes all the other values up a notch, giving you a new set of values to use. In order to make this clear we will proceed step by step.

The Front Lighting Scale

a — Draw a straight line. On it place eleven equidistant dots. Above these dots place the numbers 10 to 0. You may use any distance you wish between the dots but *all the distances must be the same.* For instance, if you wish a one inch space between the dots all the spaces must be one inch.

b — Drop a verticle from the dot under the number 10 representing white. Drop a verticle from the dot under the number 1. It doesn't matter what the depth is but be reasonable. The arrows are for clarity.

c — In the front lighting condition all the local values become a little lighter than they are. Black becomes a little lighter, and we'll call it the first value. Draw a diagonal from the dot underneath zero (0) to the bottom of the vertical you dropped from white (10). Where this diagonal crosses the vertical dropped from the first value (1) draw a horizontal line.

d — Now that we have moved black up to the first value we can move all the other values up proportionately. Draw diagonals from the dots underneath the numbers to the bottom of the vertical under white (10). This is identified as point "Y" in Figure 22c. Where the diagonals cross the horizontal draw a vertical line upward. Where this vertical touches the top line is your new value.

This scale has now transposed all your natural "home" values into a front lighting condition. Let us see what we have. Black, (0), has now become the first value. The first value (1), has become 1¾, the second value has become 2¾. Continue in this manner all the way up the line. White will have to remain white because that's all we have to paint with. These are the new values in paint that you are to use to achieve a normal front lighting condition.

I do not expect anyone to grasp this concept on first reading, but, it will become clearer after several readings and by drawing the scale step-by-step.

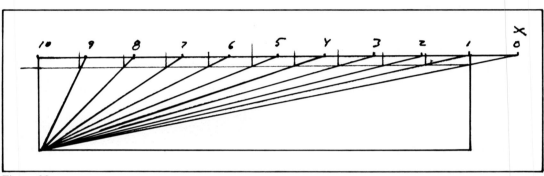

Figure 23

Front Lighting, normal condition

For a normal looking Front Lighting condition eliminate black from the bottom of the scale. Black, (0), moves up to become the first value and, therefore, all the other values move up a bit except white, which has no place to go and therefore stays white.

It is the new values on the right that you paint with in all cases. Since few people can split values as fine as a ⅛th or a 1/16th, it will be wise to stick to halves or whole numbers for all practical purposes.

Front Light, normal

White - 10 stays 10
 9 becomes 9 1/16
 8 becomes 8⅛
 7 becomes 7¼
 6 becomes 6½
 5 becomes 5½
 4 becomes 4½
 3 becomes 3¾
 2 becomes 2⅞
 1 becomes 2
Black - 0 becomes 1

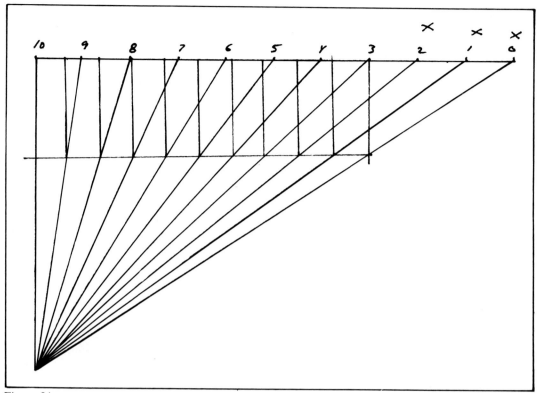

Figure 24

Front Lighting, stronger than normal condition

As we increase *the illumination of the front lighting we take more steps off the bottom of the scale, or, more simply, we make Black (0) an even lighter value. In this case black now becomes the third value. All other values move up proportionately except white, (10), which stays white.*

Front Light, stronger

White - 10	stays	10
	9 becomes	9⅜
	8 becomes	8¾
	7 becomes	8
	6 becomes	7¼
	5 becomes	6⅝
	4 becomes	6
	3 becomes	5¼
	2 becomes	4½
	1 becomes	3¾
Black -	0 becomes	3

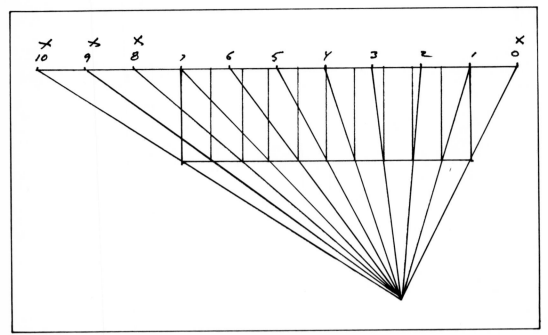

Figure 25

Front Lighting, weaker than normal condition

When we decrease the illumination of a Front Lighting condition we lower the value of white and increase the value of black. White, (10), becomes the seventh value and black, (0), becomes the first value in this example. All the values therefore condense to a point somewhere between the second and third values.

Front Light, weaker

White - 10 becomes 7
 9 becomes 6½
 8 becomes 5¾
 7 becomes 5⅛
 6 becomes 4½
 5 becomes 4
 4 becomes 3½
 3 becomes 2⅞
 2 becomes 2⅛
 1 becomes 1½
Black - 0 becomes 1

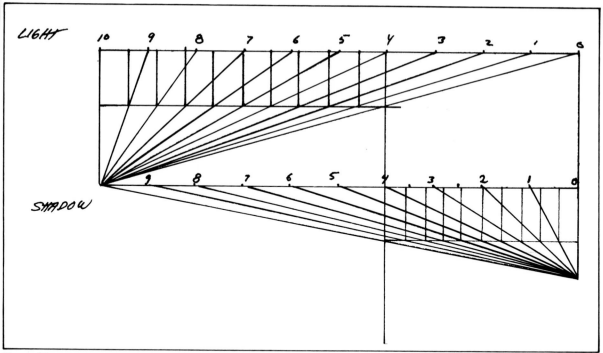

Figure 26

Form Lighting, normal condition

When an object goes into Form Lighting it goes into light and shade. We need, therefore, a scale for the new values in the light and a scale for the new values in the shadow. The top part of the scale represents the light values, the bottom part of the scale represents the shadow values. In Form Lighting the scale divides at the fourth (4th) value, that is, everything in the light will be between white, (10), and the fourth value. Everything in the shadow will be between the fourth value and black, (0). It is at this fourth value that white in the shadow is the same value as black in the light. One last note, in Lighter *than normal surroundings white in the shadow would appear slightly* lighter *than black in the light. In* darker *surroundings than normal white in the shadow would appear* darker *than black in the light.*

Form Light, normal

Light Side		Shadow Side	
White - 10	stays 10	White - 10	becomes 4
9	becomes 9½	9	becomes 3½
8	becomes 8⅞	8	becomes 3+
7	becomes 8¼	7	becomes 2⅞
6	becomes 7⅝	6	becomes 2½
5	becomes 7	5	becomes 2
4	becomes 6½	4	becomes 1½
3	becomes 5⅞	3	becomes 1⅛
2	becomes 5⅛	2	becomes ¾
1	becomes 4½	1	becomes ½
Black - 0	becomes 4	Black - 0	stays 0

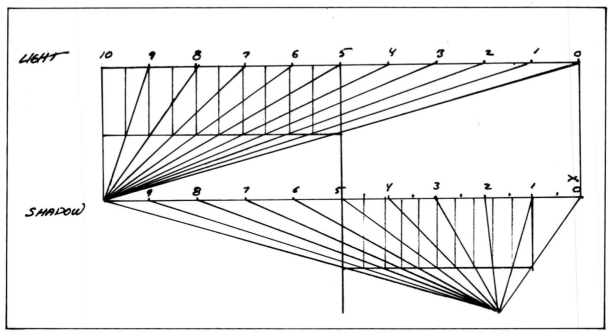

Figure 27

Form Lighting, stronger than normal condition

To obtain the feeling of a stronger than normal Form Light condition we split the scale at the fifth value instead of the fourth value. Therefore, black in the light becomes the fifth value, the same value as white in the shadow. On the shadow part of the scale, the lower part, we raise black, (0) to the first value. The shadow range is from the fifth value to the first value.

Form Lighting, stronger

Light Side				Shadow Side		
White -	10	stays	10	White -	10 becomes	5
	9	becomes	9½		9 becomes	4½
	8	becomes	9		8 becomes	4
	7	becomes	8½		7 becomes	3¾
	6	becomes	8		6 becomes	3½
	5	becomes	7½		5 becomes	3
	4	becomes	7		4 becomes	2⅝
	3	becomes	6½		3 becomes	2¼
	2	becomes	6		2 becomes	1⅞
	1	becomes	5½		1 becomes	1½
Black -	0	becomes	5	Black -	0 becomes	1

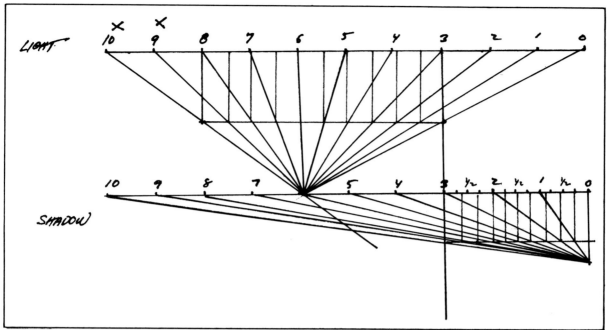

Figure 28

Form Lighting, weaker than normal condition

A weaker looking Form Lighting condition can be obtained by lowering the value of white, (10), in this case to the eighth value, and dividing the scale at the third value instead of the fourth value. The shadow part of the scale extends from the third value to black, (0).

Form Lighting, weaker

Light Side	Shadow Side
White - 10 becomes 8	White - 10 becomes 3
9 becomes 7½	9 becomes 2⅝
8 becomes 7	8 becomes 2¼
7 becomes 6½	7 becomes 2
6 becomes 6	6 becomes 1¾
5 becomes 5½	5 becomes 1½
4 becomes 5	4 becomes 1¼
3 becomes 4½	3 becomes 7⁄8
2 becomes 4	2 becomes ½
1 becomes 3½	1 becomes ¼
Black - 0 becomes 3	Black - 0 stays 0

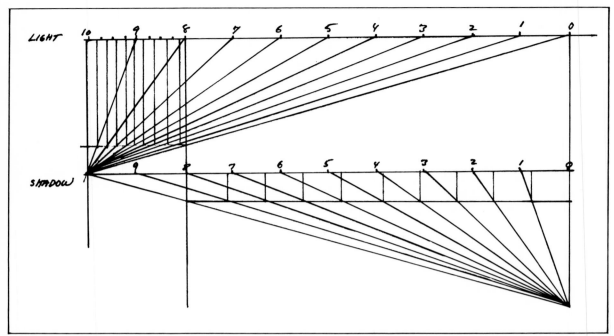

Figure 29

Normal Rim Light

Rim Lighting is basically edge lighting, usually on the side or top of the model. The light area should be no more than ⅛th of the area, otherwise you will be going into a Form Lighting condition.

As you go from a Front Lighting to a Form Lighting to a Rim Lighting condition the light values crowd towards the top of the scale and therefore appear very brilliant.

In a normal Rim Lighting white, (10), in the shadow is the same value as black, (0), in the light which is the eighth value. Therefore, the light side of the scale extends from 10 to the 8th value and the shadow side of the scale extends from the 8th value to, (0), black.

Rim Lighting, normal

Light Side			Shadow Side		
White - 10	Stays	10	White - 10	becomes	8
9	becomes	9¾	9	''	7
8	''	9½	8	''	6 ⅜
7	''	9 ⅜	7	''	5 ½
6	''	9 ⅛	6	''	4 ¾
5	''	9	5	''	4
4	''	8 ¾	4	''	3
3	''	8 ½	3	''	2 ⅜
2	''	8 ¼	2	''	1 ½
1	''	8 ⅛	1	''	⅞
Black - 0	''	8	Black - 0	stays	0

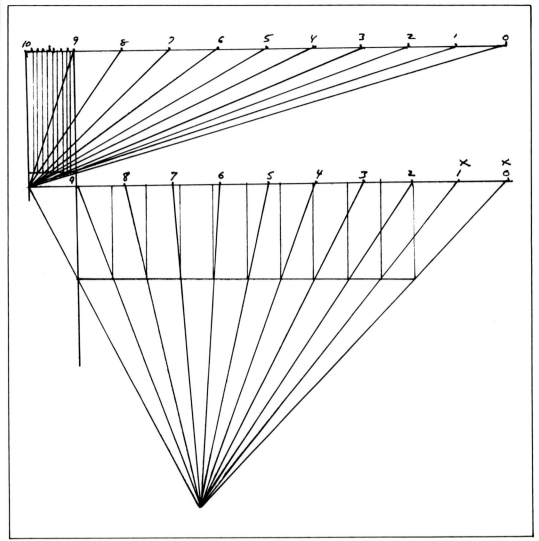

Figure 30

Rim Lighting, stronger than normal condition

In a strong Rim Lighting condition the entire scale of values condenses into a single value in the light from white to the ninth value. Rather than split values so fine merely concern yourself with white, which stays white, black, (0), which becomes the ninth value and the fifth value, which becomes nine and one half.

The shadow range moves up and two steps are also taken from the bottom of the scale, that is black, (0), becomes the second value. Almost all of your modelling with hue, value and chroma will be done in the shadow range.

Rim Lighting, stronger

Shadow Side

White -	10	becomes	9
	9	''	8 ¼
	8	''	7 ½
	7	''	6 ⅞
	6	''	6 ⅛
	5	''	5 ½
	4	''	4 ¾
	3	''	4
	2	''	3 ¼
	1	''	2 ½
Black -	0	''	2

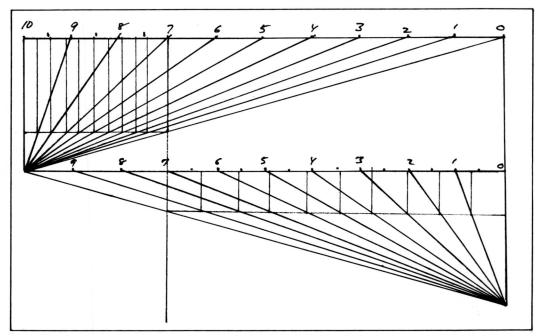
Figure 31

Rim Lighting, weaker than normal condition

A decrease of illumination or an increase of the area that the Rim Lighting occupies will produce a weaker than normal condition. The light side extends from white to the seventh value, the shadow side from the seventh value to black, (0). What this means is that white in the shadow is the same value as black in the light, the seventh value.

Rim Lighting, weaker

Light Side			*Shadow Side*		
White - 10	stays	10	White - 10	becomes	7
9	becomes	9 ¾	9	''	6 ⅜
8	''	9 ½	8	''	5 ½
7	''	9	7	''	5
6	''	8 ⅞	6	''	4
5	''	8 ½	5	''	3 ½
4	''	8 ¼	4	''	2 ¾
3	''	8	3	''	2
2	''	7 ¾	2	''	1 ½
1	''	7 ½	1	''	½
Black - 0	''	7	Black - 0	stays	0

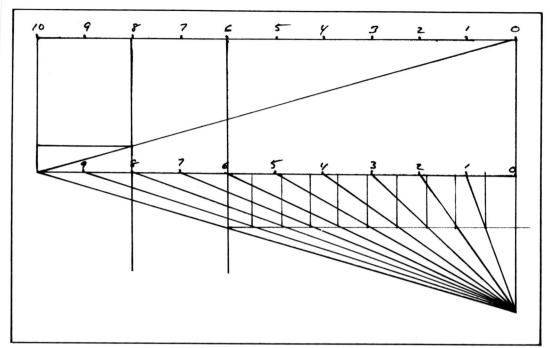

Figure 32

Rim Lighting, assuming a *dark* wall behind the model

When there is a dark wall, or a heavy dark material that reflects little light behind the model, the scale parts. The light side of the scale will stay the same as in the normal situation, but, the shadow part of the scale will condense and start at the sixth value instead of the eighth value.

Rim Lighting - Shadow Side, dark wall

White - 10	becomes	6
9	''	5 ½
8	''	5
7	''	4 ¼
6	''	3 ¾
5	''	3
4	''	2 ½
3	''	2
2	''	1 ¼
1	''	½
Black - 0	stays	0

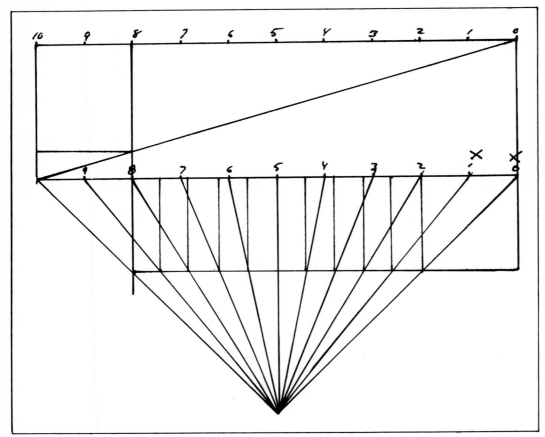

Figure 33

Rim Lighting, assuming a *white* wall behind the model

If there is a white wall or a very light background behind the model in Rim Lighting it will illuminate the shadow side more than normal. Black, (0), will become the second value and all shadow values will condense proportionately. The light side, however, stays the same as in the normal condition.

Rim Lighting - Shadow Side, white wall

White -	10	becomes	8
	9	''	7 ½
	8	''	7
	7	''	6¼
	6	''	5 ⅝
	5	''	5
	4	''	4 ½
	3	''	3 ¾
	2	''	3 ⅛
	1	''	2 ½
Black -	0	''	2

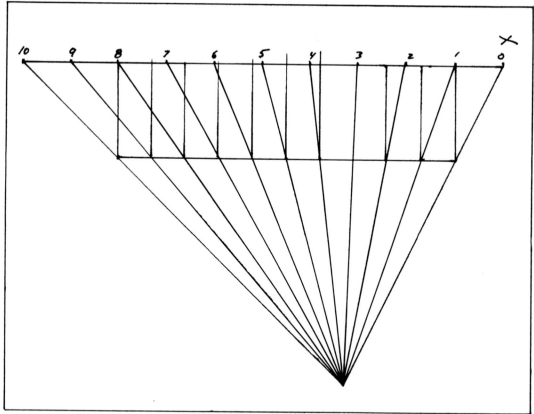

Figure 34

Back Lighting, normal condition

In Back Lighting, the light source is entirely behind the model. The light source can be, as it is in many cases, an open window. Everything we see on the model is actually in shadow. To achieve a Back Lighting effect, value-wise, we must take steps off both the top and bottom of the scale.

For a normal looking condition white, (10), is lowered to the eighth value and black, (0), is raised to the first value. All the values condense to a point near the third value.

Back Lighting, normal

White -	10	becomes	8
	9	''	7 ¼
	8	''	6 ½
	7	''	6
	6	''	5 ⅛
	5	''	4 ½
	4	''	3 ⅞
	3	''	3 ⅛
	2	''	2 ½
	1	''	1 ⅞
Black -	0	''	1

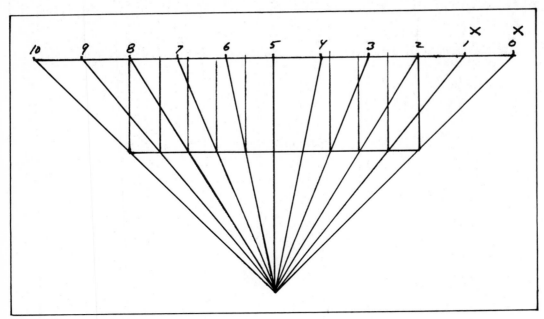

Figure 35

Back Lighting, stronger than normal condition

As the illumination behind the model increases the value of black, (0), increases. In this case black is now made the second value.

Back Lighting, stronger

White - 10 becomes 8

9	''	7 ½
8	''	7
7	''	6
6	''	5 ½
5	''	5
4	''	4 ¼
3	''	3 ⅞
2	''	3
1	''	2 ½
Black - 0	''	2

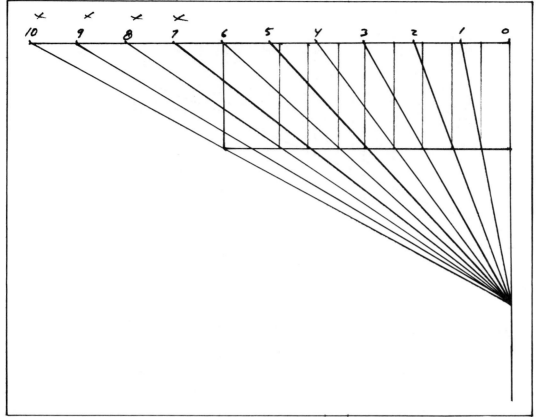

Figure 36

Back Lighting, weaker than normal condition

For a weaker than normal Back Lighting condition we must lower the value of white even more. In this instance white, (10), will become the sixth value, all other values will condense towards the lower end of the scale.

Back Lighting, weaker

White - 10 becomes 6
	9	''	5½
	8	''	5
	7	''	4⅛
	6	''	3½
	5	''	3
	4	''	2½
	3	''	1⅞
	2	''	1⅛
	1	''	½
Black -	0	stays	0

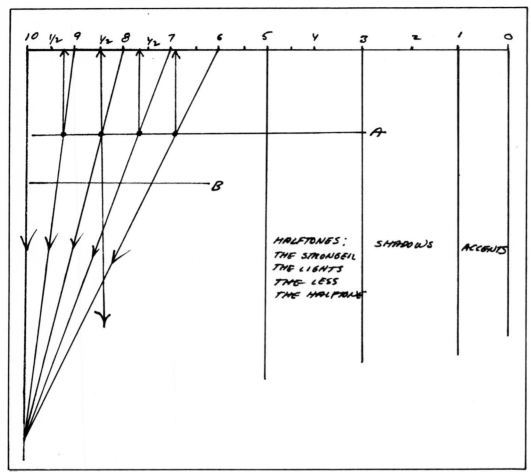

Figure 37

Scale for Boosting the Light Values for Effect

Normally we use three values in the light area. To boost these light values or any other values for particular effects we use the following method.

1. Decide what value you want your eighth value to be, say you want it to be eight and one-half.
2. Drop a verticle from eight and one-half and a verticle from white, (10).
3. Draw a *diagonal* from the eighth value to the verticle line beneath white.
4. Where this diagonal intersects the verticle beneath eight and one-half draw a horizontal, (A).
5. Erect new verticles where the diagonals cross the horizontal — this gives you your new set of values.

 Thus 6 becomes almost 7
 7 becomes almost 7 ¾
 8 becomes almost 8 ½
 9 becomes almost 9 ¼
6. If you desire a still stronger effect draw another horizontal line even lower than (A), — (B). Erect verticles from where the diagonals cross line B and you will have yet another set of values.

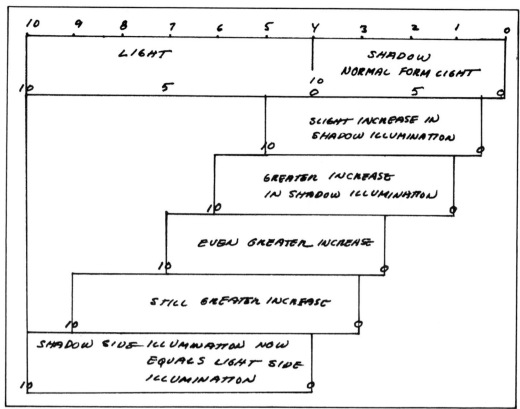

Figure 38

Scale to Show the Increase of Shadow Illumination

In a form light situation the shadow illumination can sometimes increase. This can be due to the addition of highly reflective backgrounds, secondary light sources, the opening of window shades, etc. The light side does not change, only the shadow range moves up. To figure the values more accurately follow the procedure shown in the normal and strong Form Lighting scales.

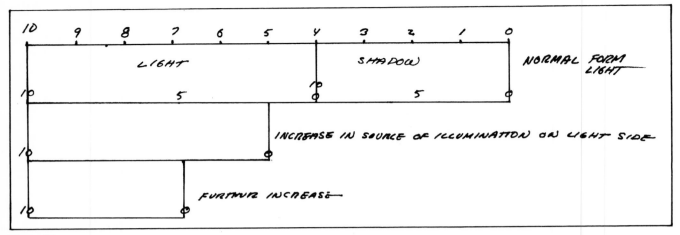

Figure 39

Scale to Show the Increase of Illumination of the Light Source

This scale shows how you can represent an increase of the source of illumination. Or, you may want to do a painting with a strong light source. In this case the light side of the scale moves up but the shadow side of the scale remains the same. *To figure the light values accurately follow the same procedure as in normal Form Light.*

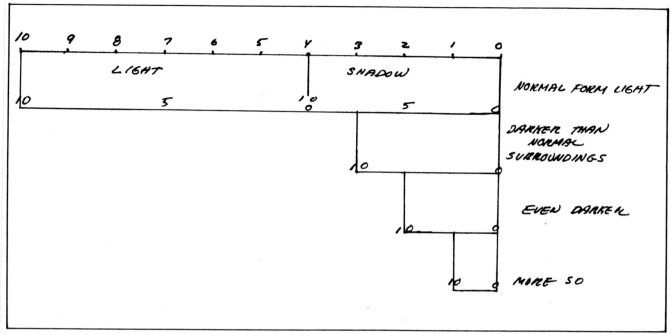

Figure 40

Scale to Show the Decrease of the Shadow Illumination

There are many elements that can cause the decrease of the shadow illumination. A highly textured dark drapery such as velvet will reflect very little light into the shadow. A bad angle of reflection will do the same thing.

For precise values follow the procedure shown in the normal Form Light scale. Shadow values, in these instances, must be kept simple.

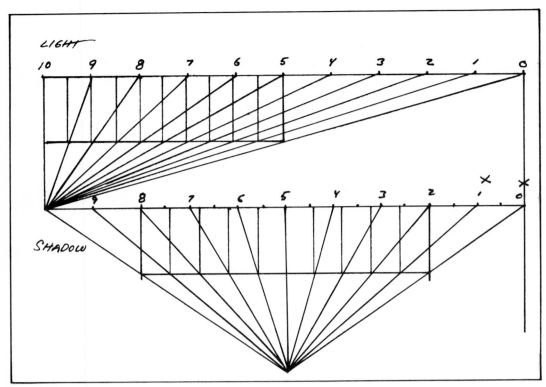

Figure 41

Sunlight Value Scale

Sunlight presents a special problem. The light side is illuminated by the warm sun and the shadow side by the cool blue sky. Since both of these light sources are strong, we have an overlapping scale. The scale shown is for values in sunlight in an open field without trees or mountains blocking the light sources. If you have a subject which is surrounded by trees, mountains, or is near a building, these elements will block off some of the skylight thus lower the value range of the shadow. You may also want to lower your shadow value range for purely pictorial purposes, or to make your painting look better in reproductions. In any case the use of these scales will allow you to paint whatever sunlight type of picture you want with complete control.

	Light Side			*Shadow Side*	
White - 10	stays	10	White - 10	becomes	8
	9 becomes	9 ½	9	''	7 ⅝
	8 ''	9	8	''	6 ¾
	7 ''	8 ½	7	''	6 ¼
	6 ''	8	6	''	5 ½
	5 ''	7 ½	5	''	5
	4 ''	7	4	''	4 ½
	3 ''	6 ½	3	''	3 ¾
	2 ''	6	2	''	3 ¼
	1 ''	5 ½	1	''	2 ½
Black - 0	''	5	Black - 0	''	2

Note: These values are for objects and materials of normal textures. A black velvet drapery in sunlight will be darker than a black piece of muslin or a black-top road as the velvet absorbs much of the light. However, if you paint it too dark you will "punch a hole" in your picture.

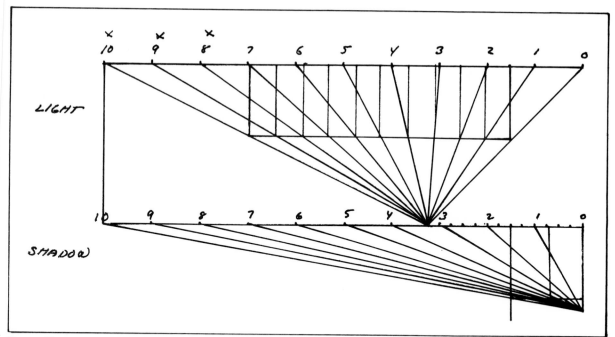

Figure 42

Moonlight Value Scale

Moonlight value determinations can be difficult as time is a serious consideration. The longer you are in a total moonlight environment the lighter the values appear and the more you'll perceive. (I once read a newspaper by the light of the full moon!)

There is, however, an average type moonlight value scale. This is based on the fact that white in the moonlight is approximately the seventh value in the light and one and one-half value in the shadow. The shadow range extends from one and one-half value to black, (0). The source of the light, the Moon, if shown in the picture will be almost pure white with a touch of yellow in it. For a moonlight that is extra bright the light range would be from the eighth value to about the third value. The shadow range would be from one and one-half to zero. All of the edges in the picture must be extremely soft. For pictorial or illustrative purposes a rim of almost pure white can be put on the subject.

If, in landscape, an atmosphere is desired, black should be made lighter, say half a value. Thus all shadow values would be within one value.

Light Side			Shadow Side		
White - 10	becomes	7	White - 10	becomes	1½
9	''	6½	5	''	¾
8	''	5⅞	Black - 0	stays	0
7	''	5½			
6	''	5¾			
5	''	4¼			
4	''	3⅝			
4	''	3+			
2	''	2½			
1	''	2			
Black - 0	''	1½			

Using the Light and Shade Scales

The following black and white studies are to show one of the practical uses of the light and shade scales. To accomplish this we will draw a simple familiar shape — (let's call her "Molly Manikin"). Now fill her in with simple, flat value-patterns. These flat value-patterns of Molly will be transposed by the use of the scales into new values. The new values, will be used to paint a version of Molly in front, form, rim and back-light.

The first illustration, Figure 43, shows the imaginary Molly with flat value-patterns (see Chapter 3). The values on a nine value system are black, (0), for the hair, white, (10), for the blouse, (4) for the skirt, (5) for the background and (7½) for the skin.

We'll now transpose these values into a front lighting condition. Look at your front light scale. Take a value average from above, say (4), which is for the skirt. Note where the diagonal from (4) intersects the horizontal line. At this juncture raise a verticle to the top line and that is your new value. In other words, the fourth value now becomes a little lighter than four and one-half in value. Do this with all the original value-averages of Molly, and you will have a new set of values conveying the broad over-all impression of Front Light. A paint sketch is now made with greys of these new values. If you followed instructions well, you will have succeeded, and you should have a great feeling of satisfaction. It is extremely unlikely that you could start with a white canvas or board and put down the correct values the first time. Even with a lot of adjustments you might find it difficult to produce the illusion of the various lighting conditions.

Figure 44a shows Molly in front lighting. Remember, these are merely your basic values. To produce form in front lighting you must darken the edges of the forms. You must not go lower than one or two values below the average along the edges and within the shapes. Lights can go up in value but they should be restricted to small areas such as top planes and highlights. Edges should be delicately brushed, for if the edges are left hard, the values would appear lighter. The edges around hair can always be softened.

Figure 44b shows Molly in form light. Once again we take the basic value-averages, place them on the form light scale and transpose them to our new values both for the light and the shadow. For this sketch you will have to add shadow planes and cast shadows. Brush some edges together here and there. Do not bother with the low lights or halftones. These additions will tend to obscure the larger value averages.

Figure 44c has Molly in rim lighting. Use the rim light scale for your new set of values. Since the light side of the scale is very narrow the differences between the values are slight. The paint should be applied crisply and heavily or else the subtle value differences will be lost. The background was arbitrarily darkened.

The last sketch, Figure 44d, Molly is painted in back lighting. In this case we will open up a window

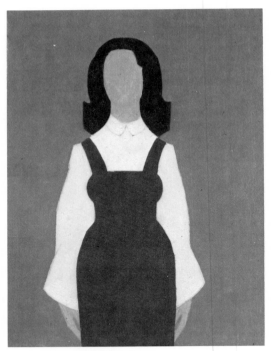

Figure 43 ''Molly Manikin''.

behind her. It will be the 9th value to represent the light coming through it. The basic value averages are transposed on the back light scale. All of the inside edges should be soft. The more intense the light behind the model the less definition there will be within the model. Outside edges with texture, such as hair, should be soft and have halation. Outside edges that are hard should remain hard; however, to produce the illusion of light bending around the edges, they should be made about a value lighter.

In back lighting form is made by painting slightly *lighter* than the value-average. Do not go lighter than ½ value or else the illusion of this type of lighting will be lost. You can go lower in value also, but not much lower than the value-average, for the same reason.

You should duplicate these examples at first. After you understand the procedure you should paint Molly in the stronger and weaker versions of the four basic conditions as well as in sunlight and moonlight.

To further improve your sense of values try changing the basic value-averages on Molly. For instance, give her a dark blouse and a light skirt. Change the value of her hair and complexion. Next put these value averages in the different lighting conditions. The combinations are almost endless but your patience will be rewarded. Doing a few of these will improve your concept of painting remarkably.

Another great benefit you can obtain from this system is that it frees you from photographic values and nature values. You can transpose any set of values from one lighting condition to values of another and have them look correct. You will be able to paint whatever you conceive, at least from the value standpoint.

Figure 44

Make a drawing of Molly and make several tracings of her — the more the better. These tracings should be on a non-absorbant surface or a fine-grained well primed canvas. Then make paintings of her in greys and black and white in many different lighting situations. Follow the instructions in the text.

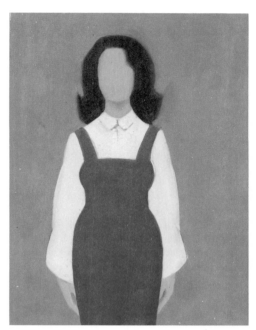

a. Molly in Front lighting.

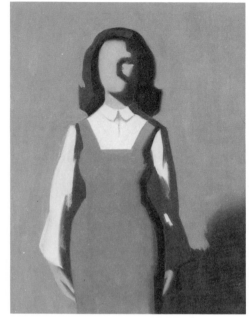

b. Molly in Form lighting.

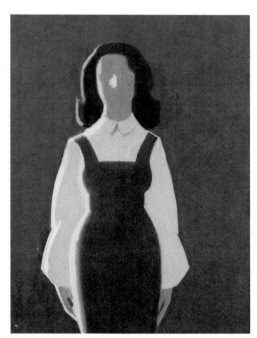

c. Molly in Rim lighting.

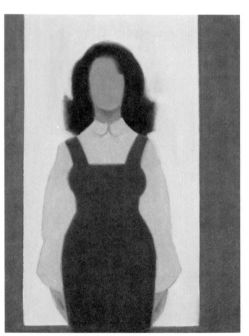

d. Molly in Back lighting.

CHAPTER 7
The Palette

Palettes vary and have varied with almost every artist who ever lived. Let's leave to the philosophers the question of why one artist will prefer one set of colors and another artist insist on an entirely different set.

A single palette with which you can paint everything, such as portraits, landscapes, flowers, etc., does not exist and never has. This may be disappointing to anyone seeking to become an instant artist. Some general discussion of the palette is needed to put things in perspective. If we analyze the palettes of artists in the past we will be in a better position to understand what we are doing and what we are seeking.

Early man used pigments that were available to him. These were organic and inorganic, from the earth, and were limited in hue. The cave paintings of the Cro-Magnon Man, if their authenticity holds up, shows a wonderful command of a few earth colors. This in itself should teach us something.

For thousands of years man worked with the same earth colors. In time a few new ones were added by pulverizing a stone, a gem, or by grinding insects and flowers.

It wasn't until 1856 that the first organic dye was produced in a laboratory. For the first time, artificial organic colors could be produced and manufactured in quantity. This greatly expanded the potential of the arts and the artist. However, some of the new colors were unstable, and many artists viewed them warily, preferring the old standbys used in the established manner.

It is doubtful that there could have been an Impressionist Movement without all the new colors industry kept producing. Armed with new colors and with some new scientific theories of the nature of light, artists of that day must have felt as children with new toys. But something was gained and something was lost. In their enthusiasm to apply the new colors and theories some artists neglected such fundamentals as firm drawing, the proper mixing of tones, and line and pattern in composition. These are weak points of some of the Impressionists. Of the period, Degas was an outstanding exception, as he did not disregard the traditional precepts while using the new colors and concepts.

Artists from about 1400 A.D. used a simple palette and an uncomplicated working method. Most of the craftsmanship, however, was of the highest order. Their concern seems to have been with "good outlines" (drawing) and the rendering of form. Color, as a vital factor in painting, came about much later with the Venetian school led by Titian, Tintoretto, and Veronese, to name a few.

How most of the early artists evolved their working methods or why they did so is not known. No doubt, the mediums they used, mainly tempera or fresco, had much to do with it. Both mediums are water soluble paint. The artists put flat values on first then added darker tones for the shaded areas and white for the lights. Blending was accomplished by using fine, dry-brushed strokes over the transitional areas.

Many beautiful paintings have been executed in tempera, both in the past and in the present. However, egg tempera is a time-consuming and tedious working method. It forces you into a restrictive technique and limits the beautiful effects of transparency, impasto, luminosity or soft blending that can be obtained so easily with oil.

The early painters in oil, notably the Van Eyck brothers, began painting much as they would with tempera. First they created a firm, rigid outline that did not allow for deviation. Next they thinned out oil color and applied it much in the manner of watercolor. Probably this area was then isolated with a varnish or a stand-oil mixture of some sort, and then painted into again to model the form. This would allow for the smooth blending of the tones and a degree of transparency where desired. When painting large flat areas such as draperies, the color was applied and varnished, oiled over, and painted into to achieve the modeling. In this manner the painting was built up step by step.

Around 1500 A.D. Holbein the Younger discovered that an opaque flesh tone approximating the model's complexion could be pre-mixed and modeled with a reddish black to produce form. This was probably the beginning of the pre-mixing of the tones on the palette.

Comparative Palettes

Figure 45a shows a reconstruction of a palette for painting flesh that could have been used by Holbein (1497-1543). The reconstruction was made by F. Schmid in 1943-44. It is based on a treatise by Valentin Boltz in 1549, several years after Holbein's death, and also by the notes of Joseph Heintz (1598), Alexander Browne (1675), Grooth (1771) and others.

On the palette we see a single flesh tone that is composed of Flake White, Light Red, Terre Verte and a bit of Vermilion. This tone was darkened with a brownish or reddish black which looked something like Burnt Umber.

Holbein painted on a firm support as this allowed for a very accurate drawing. This support had either an absorbent white surface as some claim, or a non-absorbent priming as others claim. It was tinted warm grey, a priming color that survived all the way to the days of J.L. David (1748-1825).

Holbein could model his flesh tint solely with this warm black as he left out the halftone. If he used a halftone in his modeling of flesh he would have achieved a very muddy looking complexion.

His followers seem to have added more colors and more flesh tones. The amount of hues, however, including black, did not generally exceed nine. They were the usual Yellow Ochre, Light Red, Naples Yellow, Burnt Umber, Vermillion, Black, etc. This tradition continued for about three hundred years from the time of Holbein. During this period some artists used palettes that had as many as sixty-six flesh tones to paint with.

Figure 45b shows the palette of Hogarth as he suggested in his writings in 1753. Hogarth said there were five "original" hues; yellow, red, green, purple and blue. To these hues he added an equal quantity of white and placed them in a straight line in the center of the palette. These five hues were brought up in value with white and down in value with black. This resulted in a "Gamut" of seven values and is remarkably modern looking. Hogarth did not mention if these value mixtures were to be aligned exactly one above the other, a condition Frank Reilly insisted on. Indeed, if Hogarth's plan is followed it would be impossible, for all five hues at the center of the palette start at different values. The dark side could work out fairly accurate, but the light side would require a sacrifice of chroma.

Hogarth painted by using little spots of these colors next to each other or on top of each other to obtain his flesh tones. Although such an arrangement can produce a harmonious painting, you shouldn't rush to adopt it too quickly. For one thing, Hogarth, as well as all other artists of his period, did not paint directly. There was a technical procedure of "building up" a painting which varied with each artist. Only parts of the picture were painted directly. In short, you would have to know the artist's entire technique before you could properly use his palette. Keep this in mind if you use any other artist's palette.

On technical grounds there is much to criticize. Consider these points: Much of the chroma of the original hue is lost when white or black is added to the original colors. The hues do not match each other in value, making it difficult to keep the form when making hue and chroma changes. It is difficult to obtain a cool or neutral grey even by mixing the compliments. Finally, it is difficult to make subtle chromatic changes as all the hues are full strength, since there isn't any grey to weaken them.

Figure 45c shows a typical palette from the French Academy, circa 1650. This is still a valid and logical palette. It is simple and with a couple of substitutions, fairly permanent. Such a palette is, however, useless in the hands of the beginner for reasons already mentioned. Only a student who fully comprehends what he has read in the previous chapters can properly use a palette such as this. Keep in mind, however, that these mixtures are only to facilitate the painting procedure. Don't assume you merely take a tone as is and place it on your canvas. There is much intermixing to be done between the tones and the hues for a correct painting.

A palette such as that of the French Academy presupposes much groundwork and knowledge. It is extremely difficult to mix flesh tones and even more difficult to make changes within them without losing the form of what you're painting. No doubt the students of that day drew well, were disciplined and intelligent.

Figure 45d shows a typical classroom palette for flesh colors that was originally formulated by Frank J. Reilly. It is based primarily on the work and theories of Albert Munsell (1858-1918). Reilly taught with this palette for over thirty-five years. Much excellent work was produced by the students who used it.

The palette may seem complicated but it is really quite simple. You are using only two hues — yellow-red and red, with black and white. Notice, there are nine equidistant neutral greys in a row grading from light to dark. Directly beneath the greys and matching them in value is a row of nine yellow-reds. Beneath them and matching them in value is a row of reds. These hues are as strong as they can be in chroma at all values in contrast to Hogarth's arrangement. The greys represent the weakest chroma a hue can be. The various mixtures between the grey, the yellow-red and the red *in a verticle line* produce the complexion tones, as shown in 45e. The lighter tones are for the lights, the middle tones for the halftones and the darker tones for the shadows. The section entitled Adjustments in Chapter 8 explains how this is done and how alterations can be made within the complexion gamut.

With the Reilly palette it is easier to approximate the complexion tones; easier to paint form and easier to make hue and chroma changes within the complexion without losing the values. As you advance in your studies more hues are added to this basic palette.

Figure 45e shows a palette arrangement that I used in painting an illustration. I find, as you will, that I have to alter the hues to conform to what I am painting.

Who wants to be limited to one set of hues? There are far too many diverse things in nature to limit yourself to a certain set of colors. There are flowers and sunsets and skys that cannot be painted with earth colors alone. Your palette should look like your painting.

Most artists today have at least ten colors on their palettes. These, coupled with a black and white, will produce an enormous range of colorful effects. There are however, a few things to watch out for. For instance: the Cadmiums seem to lack a certain softness and richness that the earth colors have. This is true mainly for the painting of flesh. Many artists use Naples Yellow in place of Cadmium Yellow Orange, and either Light Red, English Red, Venetian Red or Terra Rosa for their red.

Figure 45e shows a modern, simple, color keyed palette that I recommend to more advanced students. With this palette we let our hues represent our values, thereby having all the hues we need as well as our value scale. When substitutions or additions of hues are made they should be the same value as the hue they are replacing. For example, Naples Yellow can replace Cadmium Yellow Light and Yellow Ochre can replace or be above Cadmium Orange. There is a big value gap between Cadmium Red Deep and Alizarin Crimson. This can be filled by adding the Cadmium Red Deep to the Alizarin Crimson, thereby making an in-between step. You now have the nine equidistant value steps as recommended by Munsell. And you can mix your nine flesh tones if needed to match the colors above. In essence, not much has changed since the palette of the French Academy of 1650.

To the left is a large amount of flesh tone made with Flake White, Light Red and Terre Verte. On the right is a brownish-black. This was probably made from a mixture of smoke or paper-black (gelutertem russ or papyrswartz) with blood-stone (Lapide Ematites). Sometimes red chalk may have been used to warm up the black. Below is Vermilion which was used sparingly for the cheeks and lips.

I do not feel this palette is exactly right as a yellowish hue of some sort, such as Massicot or Yellow Ochre should be added to the flesh tone. This would be necessary to avoid chalkiness and to better approximate complexions. White would also have to be shown on the palette to bring the basic flesh tone up in value for proper modeling.

A palette from the self-portrait of Joseph Heintz (1564-1609), is probably closer to the truth. It shows in the center of the palette a flesh tone of Flake White, Venetian Red, Terre Verte, and possibly Massicot or some other yellow pigment. Placed around this flesh tone, going from left to right are Flake White, Vermilion, Crimson Lake, Burnt Umber, and Ivory Black. A palette of this kind would better enable the artist to approximate and model flesh tones.

Earlier artists obviously had other colors available to them but I presume they didn't use them in modeling form once they mixed up their basic flesh tone.

Figure 45a
Typical palette of Holbein's period circa 1500 A.D.

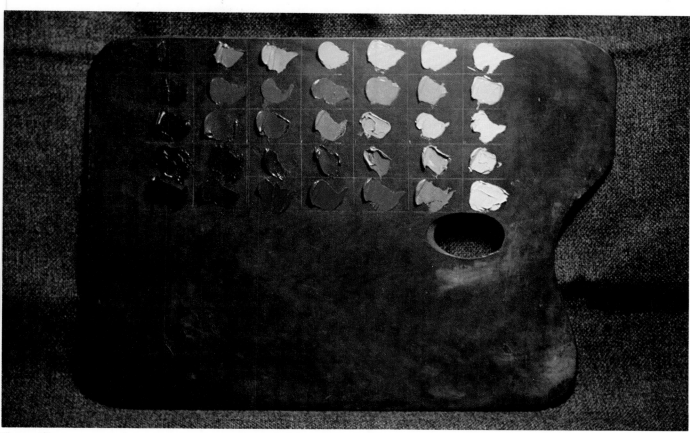

Figure 45b
Palette suggested by Hogarth from the Analysis of Beauty *(1753).*

The palette shows the three primary colors, yellow, red and blue. To this is added green, which is made from the yellow and blue, and purple, which is made from the red and blue.

The same quantity of White is added to each of these five hues and are placed one beneath the other in the center of the palette. They are Yellow, Red, Green, Purple and Blue. White is added to bring them up in value and Black is added to bring them down. I suspect this palette was more theoretical than for actual use.

Figure 45c
Palette of the French Academy by J.B. Corneille (1683).

Top row from right to left — Vermilion, Flake White, Yellow Ochre, Light Red, Crimson Lake, Brown Pink, Terre Verte, Burnt Umber and Bone Black. Below the Yellow Ochre is Naples Yellow; below the Crimson Lake is Carmine and below the Terre Verte is Ultramarine. The third row starts the flesh tones, specifically the lights. There can be four or five. Starting right to left we have White and Yellow Ochre, White and Vermilion and a little Crimson Lake; the third is the same but more Vermilion and Crimson Lake; the last light flesh tone is same with even more Vermilion and Crimson Lake.

Yellow Ochre sits between the next row, which are the halftones and shadow tones. It is to be used extensively within these tones. The row at the bottom starts reading from right to left with the first of three halftones. The first halftone is made of White, Yellow Ochre, Ultramarine and Crimson Lake. The second one is the same but with less White; the third one is the same with even less White. The last two are the shadow tones made with Crimson Lake, a lot of Yellow Ochre and Ultramarine. The darkest shadow tone is made with Brown Pink, Crimson Lake and Bone Black.

Corneille warns us not to assume these are the exact flesh tones to be picked up unmixed and placed on the canvas — there is much intermixing to do. I assume this palette is for a flesh tone in north light. Personally the reds are too strong for me — more Yellow Ochre should be added to them.

Figure 45d
Frank J. Reilly palette, when flesh tones are mixed. In use since 1933.

Top Row:
Nine equidistant neutral greys from light to dark. White should be on the left of the lightest grey and Black on the right of the darkest grey.

Second Row:
Nine equidistant values of Yellow-Reds, no lighter and no darker than the greys above them. Yellow Red is Cadmium Orange or Cadmium Yellow Orange. It is either the sixth or seventh value as it comes from the tube. Add White to bring it up in value and Burnt Umber, which is Yellow-Red at the first value, to bring it down in value.

Third Row:
Nine equidistant values of Red, no lighter and no darker than the Yellow-Reds and greys above them. Red is Cadmium Red Light or Cadmium Scarlet. As it comes from the tube it will be either the fifth or sixth

value. Add White to bring it up in value; to bring it down in value first make a mixture of Burnt Umber and Alizarin Crimson. This is Red at the first value. Add this mixture to the Cadmium Red Light to bring it down in value. For convenience one may use Cadmium Red Light, Medium and Deep, in that order, Permanent Pigments brand, for the lower values. The darker reds, however, must still be made with the admixture of Burnt Umber and Alizarin Crimson.

Fourth Row:
Nine equidistant values of flesh tones. These flesh tones are for an average skin color of a caucasion person in a studio with a north light. They are made by the admixture of the grey, the yellow-red, and the red *in a vertical line*. If the person is stronger in chroma more yellow-red is used; if the person

is weaker in chroma more grey is used, and, of course, if the person is redder more red is used. The yellow-reds and reds are all different chromas — actually the strongest they can be at their respective values.

The flesh tones, however, must be all of *the same chroma*. That is, while they grade from light to dark they must not be weaker or stronger in chroma than the other tones. Highlights are White with a touch of the lightest skin tone and accents are a mixture of Ivory Black and Alizarin Crimson.

Oil of cloves can be added to all the paint to keep it wet. Just put a drop or two of the oil on the paint with an eyedropper. Capillary action will carry the oil of cloves throughout the paint. You will need more oil in the mixtures that contain Umber and less oil in the mixtures that contain Titanium White.

The mixtures between the greys, the yellow-reds and the reds produce an incredible range of flesh tones as well as the many variations within them. For instance, an amount of grey and red produces a cool purplish-red, an admixture of yellow-red and red produces a warm orange-red. Grey, by itself, placed between warm flesh tones, will take on the compliment of those tones, appearing at a distance blue, blue-violet or blue-green.

Much painting is done in studies with artificial incandescent lighting. Under such conditions you need to place a gamut of yellows above the grey values. Of course, they should be the same value as the grey below them. It is only necessary to have yellows that match the ninth, eighth, seventh and sixth values. A small amount of yellow should be added to the flesh tone of the same value to avoid chalkiness and to give the illusion of a warm light that is pleasing in the flesh tones.

Cadmium Yellow Light, Permanent Pigments brand, is the ninth value as it comes from the tube. It can be lowered in value by the addition of a mixture of raw and burnt umber or simply yellow-ochre.

Another way to make the yellows is to use Permanent Pigments Cadmium-Yellow Medium. It is the eighth value as it comes from the tube. Add white to bring it up to the ninth value and yellow-ochre or raw umber to bring it down in value. These are especially pleasing yellows to mix into the flesh controls of the lights for sunlight painting.

Recommended Simplified Palette — for Advanced Students

Top row, left to right. White, either Titanium or Permalba. Cadmium Yellow Light, Cadmium Yellow Medium (Permanent Pigments), Cadmium Yellow Orange, Cadmium Orange (Grumbacher), Cadmium Scarlet (Winsor Newton), Cadmium Red Medium, Cadmium Red Deep (Permanent Pigments). The next red is made by mixing the Cadmium Red Deep with the Alizarin Crimson which follows it. Last is Ivory Black. For outdoor painting, however, the black should be Lamp Black. Below the black and to the right are Burnt Umber, Ultramarine Blue and Viridian.

Note that black is on both sides of the palette — it is on the right hand side to make a value judgement and bring certain hues down in value; on the left hand side it is mixed with white to make grey values. These are needed to mix the flesh tones and to grey them. Note also the Cadmium Scarlet brought up in value with white. This is needed to add to the flesh tones. The point is whenever there is a hue or chroma change in the complexion, *it should be of the same value.*

Below the hues of the top row are placed the flesh tones, corresponding exactly in value to the hues above them. The flesh tones are also all the same chroma. Different hues can be added as needed when painting.

Of course, if you are painting landscapes or bright flowers you will have to add other colors — place them above or below the color value that they match. For instance, Raw Umber, Burnt Umber, Alizarin Crimson, Ultramarine Blue and Viridian are all the same value and should all be placed near or under one another. You will eventually add or reject colors in accordance with your own feelings, just as every other artist does.

Figure 45e
Author's Simplified Recommended Palette for advanced students.

The Flesh Tones

We have talked of many different palettes that have extended over a long period of time. Let's get a bit more specific now about flesh tones as this is usually the artist's most pressing problem.

At the outset ignore all the little color changes you see either on the head or the figure. Think of the complexion as an averaging out of all the little lights, darks and colors you see from a short distance. Look for the general tone, one that belongs to a hue on the color wheel. As in the previous chapter, the way to approximate a color is first to approximate its hue. The hue of flesh varies on the color wheel all the way from green-yellow to red. See Figure 46. Basically this hue is of the yellow-red nature. Some people tend to be redder than others, while others are more yellow. There is also a skin tone that is almost green-yellow in hue — but very weak in chroma. A person with such a skin color is probably not very healthy.

Let us say our hue is yellow-red. The next step is to determine its value and chroma as previously explained.

This flesh tone can be made with any paint that is of the yellow-red hue such as Cadmium Yellow Orange, Cadmium Orange, Burnt Sienna, etc. This color may have to be greyed with various amounts of black and white, blue, or blue green and white. Once your average tone has been arrived at it has to be brought up and down in value. These tones should all be the same chroma to start. The number of flesh tones needed varies with every artist. A general consensus seems to be from seven to nine. We have already noted the early French Academicians used nine flesh tones.

I suggest you start by using nine flesh tones and the colors on top of the palette as your value guide. In other words, your tone will not be any lighter or darker than the color above it. The average Caucasian person in a normal surrounding, indoors, would be under the Cadmium Yellow-Orange paint, for no one is really "white." The lighter tones are placed under Cadmium Yellow Medium and Cadmium Yellow Light. The darker skin tones will be under the darker colors of the palette. The average shadow tone in this particular case, would be under Cadmium Red Deep; its underplane, one step darker. The darkest dark, which is an accent, would be Alizarin and black.

Adjustments must now be made. If the subject is in north light, the upper flesh tones will be cooler — toward a bluish hue. If the subject is under tungsten light then the upper tones will tend toward the yellow hue. You may also want to change the hue or chroma of the halftone or the shadow, although this is only recommended for more advanced students.

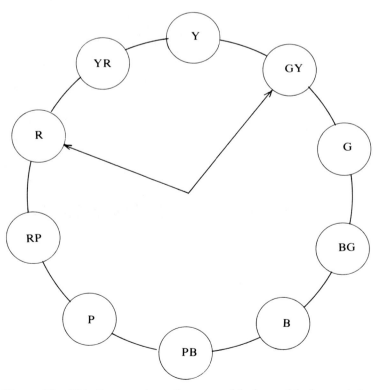

Figure 46 *This diagram shows the range of the* hues *of the human being on the color wheel.*

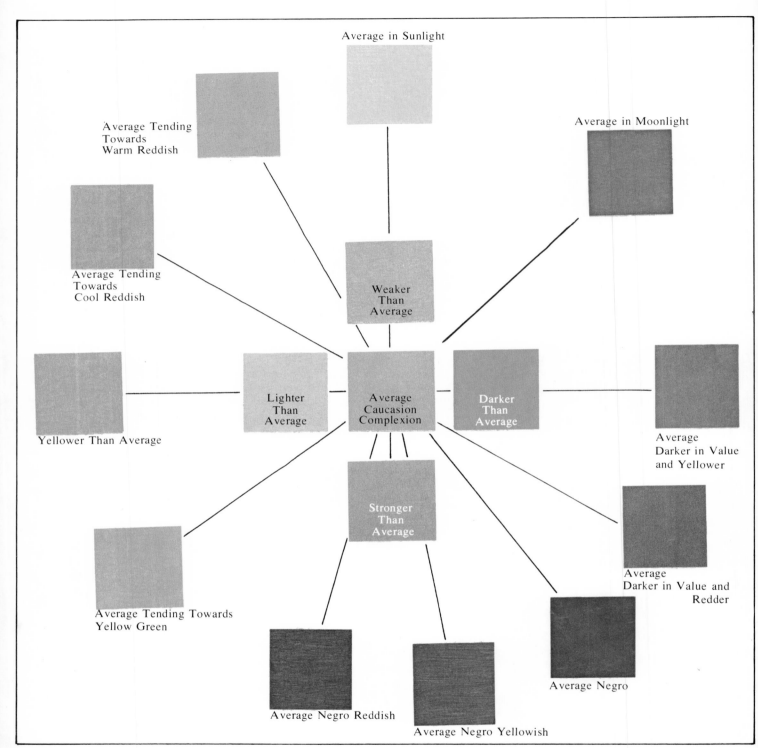

Figure 47

Complexion variations. Here we see an average caucasion complexion without light and shade on it in the center of the "Wheel". Radiating from it in all directions are variations of hue, value, chroma, and lighting conditions. Remember, these swatches are your starting point, they must be brought up and down in value properly. This is described in the next chapter on Mixing of Tones. Refer also to illustrations and figures numbered 45 c and e.

66

Figure 47 is what I call a complexion color wheel. It shows an average skin tone and some of its variations. At the center is a skin tone of an average Caucasian person indoors, the illumination being daylight. The arrangement was made for simplicity and readability. It would, of course, be impossible and unnecessary to show the infinite variety of flesh tones.

Directly to the left of the basic skin tone is an average tone of a lighter complexion; to the right is the average tone of a darker complexion. Study the chart. These tones include the "average" value range of a large portion of the human race. There are complexion tones that are more toward the yellow side of the spectrum and more on the red side. They are the same value as our average, however. These yellowish and reddish complexions can also be lighter and darker than the average tones. We see, also, average complexion tones that are weaker in chroma than our normal one and tones that are stronger in chroma than normal. Again these tones can be lighter or darker than our average.

In sunlight the flesh tone is lighter and yellower than our average complexion tone. In moonlight this tone is darker than our average. It is made with the addition of Viridian and white to the average yellow-red tone.

Directly below the average tone is an example of it with a green light upon it. This is only one example; the light can be of any hue. In any case the color, or hue used is to be brought up to the value of the skin tone and added to it. If one wants the color of the light to predominate then it is best to add a small portion of the skin tone to the color mixture representing the light rather than adding this color to the skin tone.

The complexion wheel, its tones and its variations of lightings should cover most conditions of complexion you will be called upon to paint. You can actually see the tones within the circles as your starting point. The following chapter will explain how tones are mixed.

CHAPTER 8
The Mixing of Tones

*"Tone: a shade, hue, tint or degree of a particular color or some slight modification of it."**

There are many fragments of old documents that tell of artists of a number of countries who pre-mixed their tones before they started to paint. However, little of the actual procedure or the reasoning behind it has come down to us — especially from the Old Masters. The best we can conclude is summed up in the story about an apprentice who asks the famous artist Titian how he mixed his colors. "With brains, my boy, with brains," was the reply.

It wasn't until 1849 that an English artist named Hundertpfund based his palette on Newton's theories of light and color and overthrew the time-honored practice of pre-mixing tones. Hundertpfund's palette consisted of at least twenty two different colors plus white and black. He insisted that there should be no mixtures made beforehand on the palette. Since then the "free palette" has been much in style. The Impressionists gave the "free palette" its biggest boost and many beautiful paintings came from it. The new course has also left a legacy of some rather bad painting.

I am not against painting with a "free-palette." In many instances it is preferable to pre-mixing the paint on the palette — once you know what you are doing. This type of painting, however, can cause difficulty in properly capturing complexion and form of the subject. It is difficult even for many professionals to keep the complexion looking the same as it goes from light to halftone to shadow. Also, it may prevent you from using interesting, manipulative brushwork to enhance the painting quality.

The pre-mixing of the tones survived in one manner or other with many artists, both European and American. This is not too well known but a little research will prove it. Who would guess that Thomas Sully and Gilbert Stuart mixed their tones beforehand? They did.

The purpose of this chapter then is to teach you through demonstrations how to mix the proper tones with which to paint. I've been preparing you for this all along — have you studied the previous chapters well?

Anything that you paint has a "complexion". That is its overall average of hue, value and chroma. To paint a form so it appears to be of a consistent color in light

and shade is called "holding the complexion". This is a major problem in painting, especially in portraiture and figure painting.

The Complexion Tones

Seldom does the beginner see the biggest fact about color. It is this: No matter how many changes take place within the color of the subject matter, white remains white, red remains red, black remains black and so on. The beginner usually plunges into his painting immediately, dabbing every color of his palette onto the canvas. Shortly thereafter, the white object he is painting looks like a purplish, bluish, reddish, grey mess. The red object looses its purity, black becomes grey, the lights become dirty and the painting is a disaster. He has lost the complexion of what he was painting. "That's the way I see it", is a typical student rejoinder when asked what happened.

Let's discuss this problem of the "complexion" with the use of a specific example with some variations.

Say we are painting a piece of orange colored drapery in light and shade. The first thing to do is determine its hue. This is fairly easy to do as we explained in the chapter on value patterns. You may not be able to discern the hue because it is of a weak chroma. In such case use the process of elimination. Refer to your color wheel. Merely looking at the wheel will show you that the hue is not in the blue family, or the purple-blue, green or green-yellow family. You can be pretty certain it belongs either in the yellow, yellow-red, or red family. Once you decide the hue, which in this case is yellow-red, try to pick its value. Look up and down the yellow-red spoke of the color wheel for a value that approximates what you are looking for. Now all you need is its chroma. If the yellow-red you want is the same as the one on the spoke then you don't have to do any more, but, if your color looks weaker than the one on the spoke then you have to grey it or more precisely, neutralize it. You do this by mixing a grey to the *same value* of the yellow-red and adding it to it. This then is your "complexion average". It now has to be made lighter and darker in value.

Figure 48 shows our "average" in a square at the top of the chart. The five mixtures below the square in line a, are the same color as the square brought up in value and down in value. (Remember how each hue is brought up and down in value? See Chapter 1).

You cannot use these mixtures just yet however, for

Figure 48
This exercise explains how to properly mix tonal gradations of any color and some of the more common variations that are made within them.

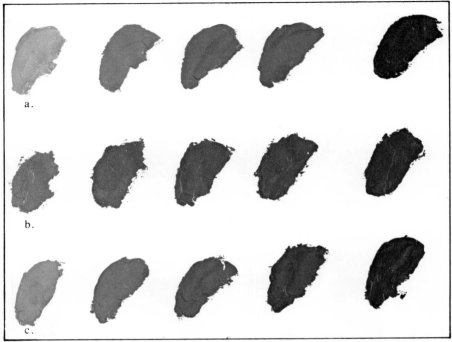

Figure 49

A colored light, blue in this case - line a, acting upon yellow red - line b. The resultant mixture is line c. The mixtures are always made in a verticle line.

they are all different chromas. They have to be approximately the same chroma to hold the complexion in most instances. You change the chroma by adding an amount of grey of the *same value* to the yellow-red. Line b shows the adjusted yellow-reds. You will have to add a lot of grey to the stronger yellow-red and little or no grey to a weaker yellow-red to accomplish this. They are now all the same chroma, and it is these mixtures you paint with. This procedure can be followed safely to paint anything you see in nature or in your imagination. It will produce satisfactory, well modeled form. Keep in mind, however, that the amount of tones will vary. Generally four or five tones are used for drapery and seven to nine tones for painting flesh.

This exercise should be repeated with many different colors. The more you do the better you will be able to discern and reproduce the infinite amount of hues and chromas around you.

Adjustments

The exercises described above should be done exactly as given. Once the principle is understood and your eye is better trained you will begin to perceive slight changes within these mixtures. You will also want to make changes due to your personal feeling about them.

If our yellow-red color mixtures are seen under north light then there isn't much change within them. However, if we put them under an incandescent light, the lightest mixture will turn a little towards the yellow hue. It will also be slightly weaker in chroma, as the light tends to bleach it out. Line c shows this change — note the tone on the extreme left.

Another adjustment may or may not have to be made in our half-tone. Let us say on line d, the fourth mixture from the left is our half-tone. There are artists who change the hue of the half-tone all the time, but this is not always necessary. The hue of the half-tone depends on the opacity or translucency of the subject, the intensity of the light on it, the position of the half-tone plane to the light, your position in relation to that plane and the nature of the hue of the material. Many half-tone adjustments are strictly an artist's personal viewpoint and are done for pictorial effect. Line d shows a change in the hue of the half-tone. Remember, no matter what hue you wish to add to the half-tone to change it, you must first make it the *same value* of the half-tone.

Line c shows a change within the shadow. Again, artists have strong personal opinions about the warmth or coolness of shadows. In this case the shadow was increased in chroma and changed in hue by adding a little red to it. If you compare this row with rows a, b, c, & d you can readily see the difference; note how the

warm shadow jumps out of context. Warm shadows have been used as a contrast to cool half-tones in order to produce the illusion of many colors when working with a limited palette. When used in this manner the shadow & half-tone have to be put on in different stages, for brushing a cool half-tone into a warm shadow usually results in muddiness.

Adjusting for Colored Light

If you want to put our yellow-red color under a colored light of any hue proceed in the following manner. For instance, if you put a bluish light on a yellow-red drapery you should mix up five blue tones to exactly the same values of the yellow-red mixtures (see Figure 49), and place them directly above the yellow-reds. Now mix the two together, making sure you always mix them in a *vertical* line, that is you use only the blue that is directly above the yellow-red. You do this in order to maintain the proper value relationships which preserve your form. How much you mix depends on how strong a blue light affects you. If you desire a very *strong* blue light effect you will find it better to *start with the gamut of blues* and add small amounts of yellow-red paint to them. Again, it is important to keep the resultant mixtures approximately the same chroma. This example can be repeated successfully with any hue.

Adjusting for Color Vibration

If you wish to vibrate the yellow-red color, say, with a yellowish-green, then proceed as follows: Make a gamut of yellow-green mixtures to the same values of the yellow-red gamut and place them directly above them. See Figure 50, line a. When painting, lay in your yellow-reds, line b, in the normal manner. While the paint is still wet add the yellow-greens of the same value as the yellow-reds into the yellow-reds without brushing them together. See line c. The effect is much more pleasing if the tones meld together. This color vibration can also be accomplished with wet paint over dry paint. You may want to try it with dots, squares, lines, or whatever you can invent. Make certain, however, that your first layer of color is thoroughly dry as distasteful effects are likely to result from a semi-dried underlayer.

If you wish to have colors vibrate that are next to each other on the color wheel you will obtain a harmonious color vibration. If you use colors that are opposite each other on the color wheel you will get a more jarring, exciting effect. *All hues* that are the *same value and same chroma* can be painted side by side, into another or on top of each other without fear because they will always appear harmonious. You can use this principle for a lifetime of painting and not fully explore all its possibilities and variations.

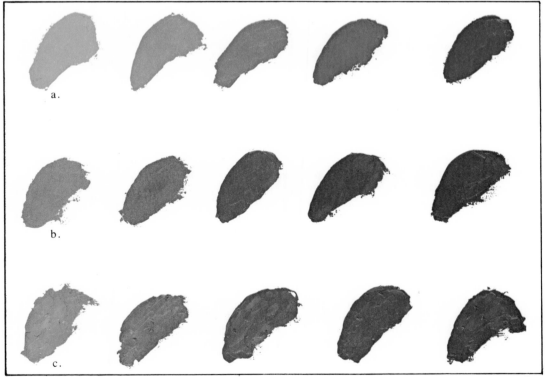

Figure 50

An exercise in color vibration; in this case, yellow-green - line a, and yellow-red - line b. Line c shows the result of this procedure. Follow the instruction in the text and see how many different colors you can vibrate.

CHAPTER 9
Edges

The treatment and handling of edges is generally regarded as a mystery. Many artists know little about them and perceive them even less. The edges we'll talk about occur within form and on the boundaries of form.

Most great painters are marvelous manipulators of edges. To do good painting it is essential to master them. Edges can create atmosphere, softness and beauty. They are also used as a directional aid by the artist to guide the eye about the picture. Edges can also influence values. Prove this to yourself by doing the simple exercises shown in Figures 51 and 53.

Figure 51 — Make two mixtures of paint, one light and one dark. Draw four rectangular boxes and paint about half of each box with the two mixtures. In the first box paint the two mixtures right up to one another and leave them. Call this the *paperhard edge*. In the second box paint the two mixtures next to each other again. Make a firm edge by drawing a flat sable brush down the dividing line of paint just once. This is a *firm edge*. In the third box apply the paint as before. Now with a clean, dry, flat sable brush drag it down the dividing line, zig-zagging the brush as you go along. When you've reached the bottom, clean your brush, and, making sure it is *dry*, gently pull it over the zig-zag. This will fuse the paint into a *soft edge*. In the fourth box, repeat everything as in the third, only make your zig-zag very wide. Now with a wide, dry brush go over the zig-zag to make a very soft edge. I will call this a *non-edge*. Notice how much lighter the paint with the hardest edge looks; conversely, how dark the same paint looks with a soft edge.

We utilize the principle of the paperhard and firm edge when we paint with close value and color relationships such as in sunlight, or when we are painting "up" in the light on the model. As we approach the finishing stage of our painting we apply the paint heavier and closer in value, chroma and hue. The paint will meld itself due to the nature of the brush. This is what Reubens must have been referring to when he said one should not "Stir them (the tones) too much." You hardly have to brush at all in the lights. In this way you can maintain the effect of a strong lighting effect as well as form. Going too dark in the light will cause you to lose the effect of the light on the model. Brushing too much in the light produces weakness of form and characters as well as lowering the effect of light.

A general rule to follow is to keep the values, colors, and brushwork crisp and close in the light. Apply paint to make your transitions, do not brush until you really have to. As you go towards the halftone and shadow you will have to brush more as these transitions are usually of a softer nature.

Reserve the hardest edge for where you want the maximum affect. Do not have too many hard edges in a picture, as a small number will balance a lot of soft edges. There are cases where painters have used only one small hard edge in the entire painting; used in this way it can be most telling.

Types of Edges

An edge can go from the hardest, to a firm, to a soft, to a non-edge. See Figure 53. A non-edge is where two tones are so similar that there is hardly any definition between them. This can occur both in the shadow area and in the light area, although it is more usual in shadow areas. Before you make a paperhard edge you should first know exactly where it is going to be. The paint that is to be applied should be heavy and devoid of most of its oil. If your paint is swimming in oil, as cheaper brands often are, place it on several layers of paper towels or newsprint and let the oil soak out. It is then ready for use. The brush stroke should be applied quickly, pressing down on the brush as it touches the canvas, and lifting it up as it nears completion. When this works it is an exhilirating feeling. However, if it does not work, you've failed. You will have to scrape it off and try again. If you think this stroke is a difficult maneuver think of the oriental artists who live by this type of calligraphic movement!

The firm edge is not as hard to do as the paper-hard edge. This type of edge is used mainly on the light of forms. If you wish to convey the feeling of roundness of form to the observer it is necessary to brush the edge of the form into the background. However, since it is on the light side it must remain *firm*, hence its name. This

edge also requires the utmost skill of execution. It is often a longer edge than the paper-hard edge and therefore requires sustained control. The brush I find best to use for this edge is a flat sable that is made for oil painting. The brush must not be too soft or too stiff. It should have a nice flexible feel to it; it must not have any other paint on it as this may produce an aberration you do not want. As for the edges, they cannot be made unless the paint of the form and of the background is wet. If the paint is dry it won't work; if the paint is half-dry it is even worse. There will be trouble also if the paint is too loose — that is too oily, as it will come off the canvas instead of staying where it should be. Too thin a paint layer is also bad as there won't be enough pigment to brush around. It takes a while to know just the right amount of paint to apply.

You have to decide beforehand the extent of the edge, for in certain places, such as rounded fleshy forms, it will turn into a soft edge and then back to a firm edge as it approaches a bony area. Make sure the paint of the background is not brushed up heavily against the paint of the form as it will interfere with your stroke. Take your flat, flexible brush and place it directly on top of the division of the background and form. With a slight, even pressure pull the brush along this dividing line, lifting your brush off the canvas as you come to the completion of the stroke.

In many cases the firm edge becomes a soft edge. To execute this passage follow what has been said above except that when you come to a point which has to be soft you must zig-zag your brush — wider for a soft edge and less wide for a harder edge — and then return to your downward stroke. This whole procedure is to be done only once. The only place you may go back to is where you zig-zagged the brush to make a softer edge. You must then clean your brush and wipe it dry. Then with a deft, dusting stroke transform the zig-zag effect into a soft edge. Again, if this is not done right you have to start over again. It takes a steady hand for complete control and a good brush. It also takes a lot of practice.

The non-edge is a favorite affectation with many art students. They love to blur everything together and then paint a little light effect here and there. They think this is terribly artistic whereas the truth of the matter is that they're either hiding a multitude of sins or simply do not know what they are doing. There is a difference between painting something in fog or snow and painting someone or something in a studio. I try to make sure the student gets his values as accurate as he can before he brushes everything together. In this way, at least, the solidity of form is maintained.

The non-edge should not be made until the values are accurately placed side by side. On the shadow side one zig-zags these tones together with a large brush, making a much wider zig-zag than in any previous edge manipulation. The next step is to take this same brush, making sure it is clean and dry, and drag it over the tones, fusing them. This step can be repeated as often as necessary for little harm can be done in this area. If the non-edge occurs in the light then you must be very accurate in the statement of tones. It doesn't take much fusing here for the desired edges to occur, for the closeness of the values will create the edge.

Edges can be brushed together without fear if the colors are harmonious or compatible, but some edges will not blend satisfactorily because the colors cause a "bleeding" effect. Alizarin Crimson, Prussian Blue, Thalo Green and Thalo Blue are especially prone to "bleed", that is they cause a staining effect you do not want. This distasteful appearance should be avoided. Figure 54 shows you how to cope with this problem. You should practice doing some of these edges so you'll be able to handle the technique when you need it. First, do *not paint the background up to the form.* Leave about a ¼″ to a ½″ space between the background and the form. (See step a.) Now paint within the space a tone compatible with the color of the form, in this case, a brown. This brown color should be the *same value* and as close to the *same chroma* as the background as possible. (Step b.) Next, brush the background halfway into this tone from the left and the form color halfway into the tone from the right. (Step c.) And finally, with a wide clean dry brush, make a downwards stroke at the juncture of the two tones to fuse them as in step d. You may brush several times as this passage must not seem obvious to the eye. In this manner the edges are properly brushed and the "bleeding" effect is avoided.

Edges and Painting Styles

Edges have to be thought of differently depending on the type of painting you are doing. If the painting consists of a single figure or portrait then the main concern should be with the variation of the edges within that subject matter. The best works of Sargent, Velasquez, and Hals are full of excellent examples of these types of edges. If however, you are painting a picture with a foreground, middle ground and background your main concern will be with those planes. In this instance you alter the edges within a plane depending on where you want the viewer to look. Vermeer is an excellent artist to study for this approach. He focuses our attention on the plane he wants us to look at by softening most of the other planes. Even his highlights are softened within the plane that is out of focus.

For a long time a school of painting has existed that does not believe in brushing outside edges at all. This is a stylization and technique that is not taught in this book as the subject is too vast. However, if you wish to paint in this manner you should be aware the entire picture relies on decorative effect. All shapes, contours and details have to be beautifully designed and drawn. The appearance of edges will be created by the contrasts of values or by dry brushing paint over paint.

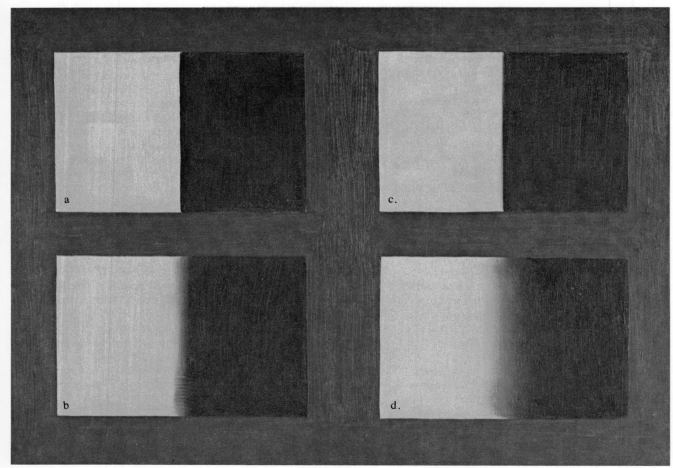

Figure 51

a. The paperhard edge is used on edges of thin flat planes and objects. It attracts the attention and makes forms project. It is best used when modeling with close hue, value and chroma.
b. The firm edge. The basic edge is used in painting of the figure and portrait as well as still-life objects. It is mainly found on the light side.
c. Soft edges are used most often on the shadow sides of forms. They are useful as well on rounded and receding forms within the light area.
d. The non-edge — the softest edge you can make. It is used whenever the value of the subject approaches the value of anything else near it. This happens mainly on the shadow side, but can also occur within a light or halftone area.

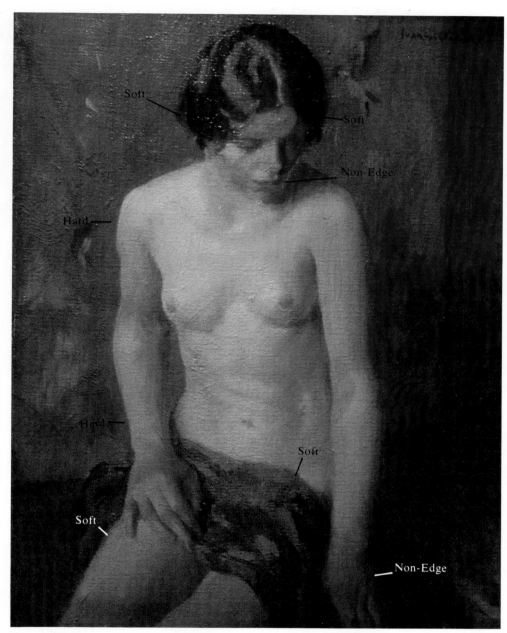

Figure 52
*A fine example of the treatment of edges in a figure painting by
the American artist Ivan G. Olinsky.*

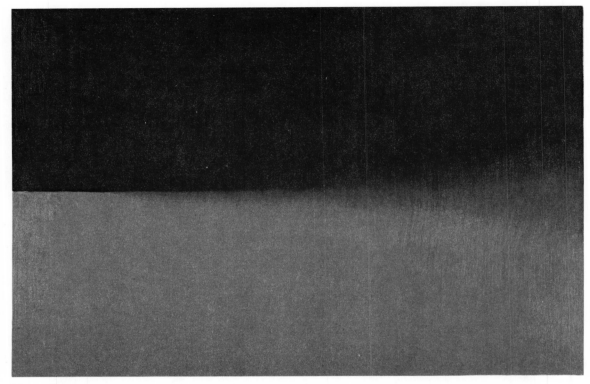

Figure 53

Here is the transition, from left to right, from a paperhard edge to a soft edge, to a non-edge. Note how much lighter the red appears with the paperhard edge. This proves the same colors appear lighter with a hard edge and darker with soft edges.

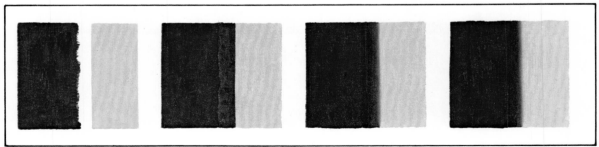

Figure 54
Four steps showing how to make a soft edge and avoid the distasteful "bleeding" effect which destroys the purity of your color. "Bleeding" will occur when using certain colors such as Alizarin Crimson, Thalo Blue, Prussian Blue and Thalo Green to mention a few.

CHAPTER 10
Approach

The approach and execution of a painting is always a problem. How do you start . . . how do you overcome that blank canvas that stares back at you defiantly? There is no easy answer. And, certainly, it is beyond the purpose of this book to describe the myriad of possibilities open to you.

Many beginners feel their timidity and inadequacies would be overcome if they could master a technique. This is really putting the cart before the horse. Technique and style will develop almost by itself as you become more competent in your skills and are surer of what it is you want to say with your painting. Having said this — and believing every syllable of it — I'd like to discuss with you how paint is applied and what you can hope the results will look like. The emphasis will be on broad approaches to painting. With experience you can be confident you'll discover your own road. In the meantime, have a good look at the ways open to you.

Keep in mind, what we are talking about deals with methods of applying paint, *not* what is being painted. The procedures are pertinent to any painting approach be it representational, abstract or anywhere in between.

Generally, there are two approaches to painting. One is usually referred to as *painterly*. The German word, "Malerische" is used in this connection. Here the artist paints quite freely, applying paint rapidly, both thinly and thickly without much regard to the modeling of the individual forms. The artist views his entire scene as a flat plain broken up into different sections of shapes, colors and values. In a way it is somewhat like a jigsaw puzzle. The artist tries to match what he sees by painting everything on the canvas in an overall relationship. If everything is successfully laid-in then he may or may not model some forms more completely, brush things together here and there, strengthen some edges, and the painting is completed. If the painting does not "come off" as we say, then it is scraped down and started all over again. "Alla Prima" paintings, that is paintings that are finished at one session, usually done in the "Malerische" manner.

The other type of painting is called *rendered*. In a rendering everything is first drawn with considerable accuracy. Usually the drawing is then traced onto a panel or canvas. At times, such a drawing may be inked over, using a diluted india ink, with a sable brush or pen. The painting then progresses with individual forms delicately modeled to produce the illusion of form in space. At a later stage all the individual planes and forms may have to be restated so as to better adjust to the overall picture.

In another rendering procedure the artist may work on a well primed canvas or panel, using only a light pencil drawing and a color sketch to go by. The paint to be used is carefully prepared in advance. It is applied directly, very thinly at first, working from light to dark. The modeling of the forms is made by allowing the white ground to show through the thin paint. The thinner the paint the lighter the value. As thicker paint is applied the surface becomes more opaque and appears darker. This produces the modeling.

Between these two extremes are all the other techniques of painting. Both methods, if carried out to their ultimate conclusion, can come to surprisingly similar results. The Malerische method may be described as painting the illusion of light or form, whereas the Rendering method is the painting of the actual form. Malerische allows for a more individual interpretation, more of the artist's handwriting, and virtuosity, is shown. If carried to the extreme, however, it can become egotistical — that is, the artist gets more involved in his fancy brushwork rather than what he is painting. The same danger applies to renderers. Renderers usually get better and better at it. After a while they feel they have to render everything so much so that the painting's ultimate goal will be to look exactly like an Ektachrome. The picture as a whole is overworked and the detail can weary the viewer, much as the rendering has wearied the artist. Knowing where to stop is of primary importance in producing a work of art. That takes taste and discretion.

As you paint, your inner feelings will dictate the way you will go. A decision should not be made in the early stages of training. For both teaching and learning purposes though, I believe a direct form of painting is a good choice, especially for beginners. It allows you to make a definite statement in terms of hue, value and chroma. And, the paint can be altered or manipulated easily. It also will allow you to produce a fine painting in a reasonable time with permanent results.

Figure 55
A portrait started in the "Malerische" manner by the author.

Figure 56
An example of a "rendered" portrait by the author.

CHAPTER 11
Starting the Painting

Every artist starts his painting a different way. And, many artists start their paintings many different ways. We all develop our own personal technique based on our ability, temperament, knowledge and skills. Much depends on what we want to say and how we say it.

I have found over the years, both from my own work and the works of others, that early efforts are usually rendered in a tight manner. With age and experience, and perhaps a little impatience, we start to leave out some of the preliminary steps, and paint more directly. Gradually, we leave the "rendering" method and try to paint more in keeping with what we see or imagine. A clear example of this can be seen in the works of Velasquez. His early efforts are tightly rendered, emphasizing form. Later his paintings become more visually oriented. In one of his last works, "The Maids of Honor" painted in 1656, Velasquez emphasizes the visual impression to such a degree that the tactile sense of form is almost lost.

Rembrandt also progressed somewhat in this manner. His earlier portraits were smoothly rendered forms while the paintings done in his last years were with thickly loaded impastos. The contrast of these thick impastos in the light areas with the thinly painted luminous shadows gave the illusion of light on form.

Frans Hals and John Singer Sargent are two more artists whose brilliant brushwork beautifully created the illusion of forms in space.

It would be presumptuous of any teacher to give you an iron-clad painting procedure and tell you to follow it. For me to do so here would be particularly misleading as there is so much I do not know about you. I do not know if you are a beginner or an advanced student. I do not know if you intend to paint murals or miniatures. I do not know if you like to render form or suggest form. I do not know if you have monk-like patience or no patience at all.

However, if you were a student of mine at the Art Students League, I could put you on a definite program and help you to evolve, step by step, into as competent a painter as your ability and desire will allow. This could be done because I could see at what stage of de-

velopment you are and how quickly you absorb knowledge. Short of becoming a classroom student of mine I suggest you follow the instructions in this book step by step. Be sure you understand what you are reading and doing before going on to succeeding steps.

We now come to a point where we must apply all this knowledge and acquired skill to actual painting.

Let's discuss four basic ways to start a painting. They have always been used and are still in common use today. Basically, they encompass all the major ways to begin a painting. Use any of the methods you feel comfortable with and are compatible with your present stage of development, your temperament and talent. It would be wise to practice all four procedures so you'll know what they are all about.

Also, at times you may find one procedure more advantageous than another.

Aside from the fact I do not approve of them, such highly individual techniques as painting over a black and white monochrome or painting with glazes over brown, white and black monochromes, are not discussed in detail here as the subject is too vast and varied. However, since many students ask me about painting over a black and white monochrome I feel obliged to offer this brief observation: In general, students tend to place all Old Masters in the same age, if not living in the same town at the same time. Apparently, the old gentlemen are visualized standing back to back, covering black and white monochrome with glazes and scumbles. With few exceptions the young student's sense of history is as muddled as his visual perception.

Of course, the Old Masters were remarkable individuals of many nationalities, living in many different places over a long period of time. Each worked in his own technique — techniques that often varied as his career progressed. Surely, some of the Masters made monochrome preparations or studies at times, but few if any did so to the exclusion of other procedures. Any close study of the great old paintings will reveal as much variety in their execution as do the paintings of today. As far as I know there is no reliable source describing the complete working methods of the Masters.

Therefore, it is wise to ignore conjecture and stick to tried and true procedure. Enough said about painting over monochromes.

It's important to repeat that all the lessons of the previous chapters should be learned well for the proper execution of any of these starting procedures. Otherwise, if you encounter difficulty you will not know if your failure is due to your lack of knowledge, or by the way you have approached your painting.

It is the intention of this book to teach you to see, to think and to do. How you do it will be left up to you.

Figures 57a, b, c and d show the four basic methods, partially started to give you an idea of how to proceed.

The White Canvas

The first method is to apply the paint directly to a pure white canvas (Figure 57a). This method is deceptively simple. For a satisfactory conclusion you would have to be able to draw with the brush like a master, putting the right tones in the right place, right off. To say the least, this is difficult to accomplish unless you have long experience in drawing, controlling paint mixtures and values.

If you start painting with the lights, let's say an average flesh tone, they will appear dark and murky against the white canvas. The beginner is likely to lighten the tone and make it more chromatic. After everything else on the canvas is stated the skin will look too light. Now, the novice will try to correct the problem by darkening it. This results in muddy complexion, or the darks now become too light. Naturally, all the careful work that went into modeling the form in the earlier stages is lost in the process. Another difficulty is that the surface of the white canvas has a nasty habit of showing through where you least want it. When you try to cover it up you usually spoil a nice brush stroke, or your drawing, and have to do it again.

In this method the initial statement can be made with hard vine charcoal if it is on a large canvas, or a 5 H lead pencil if you are working on a small canvas or panel. Or, you can use an Umber or any neutral tone diluted with gum turpentine to make your drawing.

If charcoal is used it should be sprayed with a thin coat of charcoal fixative. The actual paint is applied directly from the tube, diluted only when necessary with gum turpentine or linseed oil or both mixed together. Mediums should always be used sparingly. The entire canvas should be covered with paint as quickly as possible. The next day you may find that the paint has started to dry unevenly. If this happens spray the painting with a very thin coat of Damar Retouch Varnish to restore the sunken values and to reunify the painting.

Painting is best accomplished if the paint is either all wet or all dry. If it is in a tacky, half dry stage it makes matters difficult and often produces an unpleasant surface appearance. Many artists simply scrape the paint-

Figure 57a.
Painting started directly on a white canvas without any preliminary underpainting or drawing.

ing down with a scraping knife or palette knife and start all over. The scraping-down prepares the surface to be painted on again as well as creating a unifying undertone. Some artists scrape down this first stage as a matter of course.

If you wish to keep your paint wet more than a few days, add a drop of Oil of Cloves to each of your colors and tones. The oil merely has to be dropped on the paint, capillary action will carry it throughout. You'll find you need more Oil of Cloves in the Umbers and less in the Cadmiums.

If you wish to make your paint dry faster, there are two common ways of doing it. One is to take most of the oil out of your pigments by placing the paint on newsprint or paper towels to let the oil seep out. Next, take the colors off the paper, place them on the palette and mix in a small drop of Cobalt dryer with your palette knife. Also, you can speed up drying time by using a mixture of linseed oil, gum turpentine and a drop or two of Cobalt dryer. If you use this mixture as you paint your painting will be dry the next day. Experience will tell you the proper proportions to use but be careful with the Cobalt dryer, use it sparingly.

Figure 57b

The Toned Canvas

The second method of starting a painting is to paint on a toned canvas (Figure 57b). This is a more traditional method, and it's been widely used for over four hundred years. The tone we are talking about is not a thin wash of color, but a solid opaque layer of paint. The tone is the final layer of several primer coats. Priming coats were — and are — usually made with Flake White over a glue size. The tone was a mixture of Flake White and Black. Sometimes this tone was yellowish, sometimes grey and other times reddish. Titian and Tintoretto seemed to prefer a dark grey. The Venetians such as Guardi and Piazzetta added a large amount of Red Ochre to the grey. Nicholas Poussin (1594-1665), and the rest of the French school of that period preferred a reddish tone also. Rubens seems to have used any thing from a pure white ground, to a grey ground to a warm transparent brown. It all depended on what he expected to achieve.

Artists who used a dark toned canvas usually drew on it with a light chalk. The chalk may or may not have been drawn over with a dark color, diluted with oil or varnish and applied with a sable brush. The shadows were applied thinly with oil or an oil-varnish mixture. The lights were placed on firmly and directly. In some areas the lights were applied thinly. This was where the toned background was allowed to come through to produce both transitional tones and the beautiful optical greys which we admire so much in some of the old master works.

After the first statements dried the canvas was sprayed or coated with a retouch varnish and painted on again. Or, it could be rubbed with a thin coat of poppy oil and then painted on with the more intense colors.

The color of the background tone, whether it be warm or cool, its value, and whether one paints into a fresh thin coat of retouch varnish or poppy oil is left up to the artist.

The Imprimatura

A third method is one that has been in use in some manner or other from the time of the early Renaissance (Figure 57c). The Italian word for it is "Imprimatura". It is a full value transparent underpainting. Essentially, a thin wash of Raw or Burnt Umber mixed with linseed oil and gum turpentine is applied over a white canvas. This overall tone can be placed over a pencil drawing which has been drawn over with a sable brush and diluted india ink. The ink is diluted for if it is used full strength it will be seen through the more transparent passages.

With this method you may draw as much detail as you want. The tone is then applied and allowed to dry overnight. The paint mixtures are then applied over the umber tone. You need not worry about the white canvas showing up in wrong places or losing your drawing. If you make errors or don't like what you've done you can always scrape or wash off all the paint and begin again — your drawing is always there. The brown can be allowed to show up here and there to act as a sort of unifying tone to the painting. This method allows you to work rapidly.

Imprimatura has other advantages. It can be a great aid in both learning to paint as well as an aid to the completion of the painting. The tone is applied wet and oily and because of this it can be manipulated freely and with ease. You can draw or block in your subject by applying pure umber with a stiff bristle brush over the wet tone. There is no problem of placement as the oily umber tone can be pushed around easily. The lights are made by rubbing off the wet tone with a piece of lint-free cloth such as cheesecloth. By rubbing to the white canvas you have your lightest value. By gently rubbing the tone you produce a value darker than white. The harder you rub the lighter the value. Darks are made by restating with pure umber. Edges are softened with a two-inch, soft, dry cutter brush. This brush is to be used only for "dusting" and softening. It should always be used clean and dry. In this way you can position your subject easily, get good drawing, good values and good edges. Since it is the light and dark aspect of the color, that is, its value that makes most of the form, this helps solve one of your biggest problems.

The beginner should first practice doing as many black and white value pattern studies as he can. Examples of these are shown in Chapter Five. When the idea of value-patterns is understood he should go on to imprimaturas. These should be done over and over again. When you feel you are sufficiently capable of seeing and executing good drawings, values and edges you are ready to apply full color.

It is important to state here that when the paint is finally applied the value of the color should be the same as the value of the umber tone beneath it, otherwise you are ignoring a major reason for making imprimatura.

The imprimatura can be carried to two endings. It can be a finished, full value monochrome; or, it can be carried to a general finish, that is, without details such as small planes or highlights. There is a painting at the Metropolitan Museum of Art in New York City by Jean Honre Fragonard (1732-1806), called "The Love Letter". A large area of it clearly shows a warm umber imprimatura of this general sort. The full color opaque tones are thinly painted over it. The tones seem to have been diluted with an oil to blend them into the imprimatura. Whether Fragonard intended this to be his finish or his start is something only he could answer.

In the fully finished state many imprimaturas can stand by themselves as works of art. If color is added, and this is done only after it is dry, the umber tone must be matched exactly throughout. If the imprimatura is carried to a general conclusion then you paint in the broad averages, brush them together and then paint in the smaller forms, planes, highlights, accents and details. Both approaches can bring satisfactory results.

Technical Aspects Concerning The Imprimatura

The imprimatura is made with Raw or Burnt Umber which is applied with a mixture of linseed oil and gum turpentine. It is wise to try to standardize things to facilitate learning and to avoid grief later on. You should be able to concentrate on what you're painting rather than trying to overcome technical difficulties. I suggest you use one type of canvas and start with a half and half mixture of linseed oil and gum turpentine. Use a good brand of umber paint as it is not expensive and it goes a long way. The better the umber the better it is in the wash and the better the luminosity it'll give to the painting.

As for the canvas, a heavily primed linen is the best. However, it is expensive and not really necessary. I suggest a good double primed Cotton Duck. Ask if the canvas is primed with an oil based paint or an acrylic based paint. Many manufacturers do not state this and it is important to know. If you have a choice select the oil base prime as not much is now known about how well the acrylic prime will hold up.

Your canvas should be stretched as taut as you can make it. Next tap the pegs in gently, and then wet the back of the canvas with water and a sponge. When this dries the canvas will pull even tighter. If this is still not taut enough then tap the pegs in some more.

The next step is to rub down the surface of the canvas using a rag and pure linseed oil. Do not use too much oil as it must be a mere breath of a film.

Now apply the umber. I prefer the umber from the tube to be of a stiff nature, not oily. Apply the umber with any large brush, dipping the brush in your mixture of oil and turpentine to dilute it. Put the umber over the entire canvas. Try as best you can to approximate the value of the model's shadow with this overall tone. This tone should be even without any higgidly-piggidly brush marks that may interfere with your

drawing. You may find you may have to gently rub the tone down with cheese cloth in order to get it even looking and of the right value.

It is into this flat tone that you draw in your subject, stating darks, rubbing out lights, feathering the edges or "dusting down" a value that is too light.

The drawing is made with almost any pointed object. The handle-end of a brush works fine, so does your fingernail wrapped around a piece of cheesecloth. Also, the hard rubber eraser at the end of common lead pencils works well in the wet wash.

You may now run into your first technical difficulty. The tone you put down may soak into the canvas too rapidly. This is because your canvas is too absorbent and soaks up the paint like a blotter with ink. To overcome this you will have to use more linseed oil or less gum turpentine in your mixture. If you find your umber wash is too oily and slick, preventing proper modeling, then there is too much oil in the mixture or your canvas surface is not absorbent enough. In this case you add more turpentine and use less oil.

After a while you will find which mixture works right for you. When found you should bottle the mixture and always use it with the same type canvas.

In the beginning, you may want to make many imprimaturas as studies but you'll find that a lot of canvases are expensive. Many of your early efforts are not going to be worth saving so I suggest you gesso right over them with acrylic gesso and start again.

If your umber is still wet wash it off with a rag and mineral spirits or turpentine. After you remove as much of the brown wash as you can and after the surface is dry cover it with a thin coat of acrylic gesso. This should be dry in about twenty minutes. Then cover it with another coat, making sure to follow the instructions on the container. When dry and the canvas surface is entirely white again you can make another "imprimatura". The acrylic gesso is recommended here because of its rapid drying and brilliant white surface. In this way you can use the same canvas two or three times for studies. Remember, use several thin coats rather than one thick one. Try to maintain the tooth of the canvas, as a slick surface is difficult to work on. If you find yourself with an undesirable slick surface, coat it with the acrylic gesso using vertical strokes; when dry cover it with horizontal strokes. Use a bristle brush to help preserve the strokes. This textured effect will provide a good surface for your paint to cling to.

The above is for studies and class painting. When doing a finished painting you should decide beforehand what kind of surface you desire to paint on and what kind of "look" you want in the finished painting. The canvas surface should be prepared with the finish in mind. The oil and turpentine mixture may have to be adjusted to work over the acrylic priming.

Some artists use acrylic gesso on any canvas before they start painting as it produces a brilliant white surface. The appealing surface, shining through the layers of pigment, may enhance the colors. Remember, how-

ever, acrylic gessos have not been on the market long enough to vouch for their permanence. Also it is criminal to gesso over a well-primed linen canvas.

Good, double primed, Belgian Linen is said to be the best surface on which to paint, but a lot depends on who primes it and what it is primed with. Also not all linen is superior to all cotton duck. Often good double primed cotton duck is better than a low grade badly primed linen. For my own purposes I prefer a double primed linen or cotton duck canvas, primed with Flake White. My second choice is Titanium White. Canvas primed with Shiva Oil-Underpainting White is satisfactory and acrylic gesso will do.

The Color Wash

The last method we'll discuss is commonly called color-wash, see Figure 57c. This is often used in illustrations, murals, or story telling pictures where there are many figures and colors. It can be executed on wood or masonite, canvas or canvas panel. When canvas is used it should have a very fine tooth.

Some artists tack the corners of the canvas to a board

Figure 57c

Figure 57d

rather than put it on stretchers. The firm support allows them to draw and paint with greater detail and accuracy. Panels can be primed with acrylic gesso, Flake White, Titanium White or Underpainting White. The usual precautions have to be observed, such as sanding the surface before applying the priming, sanding between the coats and applying several thin layers rather than one or two heavy ones. If any sort of glue size is used, the strongest size must be the bottom layers — the succeeding ones being weaker.

The surface of the panel should be smooth but not slick as glass. Use a hard graphite pencil for your drawing. Then go over the pencil lines with india ink diluted with water, applied with a fine sable brush. If the india ink will not take on the surface add a drop of Photo-Flo to the mixture. The drawing should be a mixture of fine lines and dry brush and be a work of art in itself.

Before you start applying the opaque tones you should have a fairly accurate and complete color sketch, if you are not working from life. The sketch serves as an essential guide for your color wash. The tones to be used in the painting are then mixed up on the palette. Although this seems like a chore you will find that the more tones you mix up the better off you will be when painting and the more time you will save later on.

Now comes a problem. When you apply the opaque

tones thinly and transparently they may look like anything except what they are supposed to look like. For this reason you have to test various colors such as Yellow Ochre, Burnt Sienna, Light Red, etc. that look different when transparent. For instance, a Yellow Ochre and a bit of Light Red will look like a strong flesh tone when made transparent. The colors should be tested with a little oil on a surface identical to the one on which you are working. When initially applied to the inked drawing they should be neither completely transparent nor opaque.

Everyone has their favorite medium for diluting paint for application. Turpentine should be used sparingly as it dissolves the paint too much and it may cause the paint to run and crack later on. Oil can be used but it requires a large amount of it for permanent painting. It would also alter the paler tones and blues too much. Later it may rise to the surface and yellow some more. Besides, the underlayers would take too long to dry and might cause cracking at a future date.

A good time-tested medium to use would be 1/3rd sun-thickened oil, 1/3rd Damar Varnish and gum turpentine. One or two drops of Cobalt dryer should be added to this mixture. This mixture will allow the dilution of the paint without having it run, maintain its luminosity, adhere to the surface and allow blending.

First apply the paint thinly on flat surfaces working from light to dark. Where forms are to be painted use one light tone and one dark tone. The light one is put on first, taking care not to be too opaque nor too transparent, the shadow areas are then added and slightly blended into the light, much like a watercolor. The entire painting at this stage is covered with flat tones that approximate, but are not exactly the same as the final. There is not much form at this stage as the in-between tones and halftones are missing.

When completely dry, the opaque tones are boldly applied over it and brushed together where needed. In some instances the opaque tones can be brushed subtly into the color wash. Some of the color wash may be allowed to come through to add sparkle to the painting. The contrast between the opaque paint and the transparency beneath will enhance the surface quality.

The portraits by Holbein show a technique similar to the above. However, instead of applying the paint opaquely over the entire color wash he used thinned layers of color. These he applied one over the other until his modeling was complete. However, in the flesh areas and other opaque appearing objects such as flowers, the opaque paint was applied directly and heavily over the color wash. It is likely that a thin coat of varnish sealed each layer and it was not painted over until dry.

Figure 57e

Finished Painting

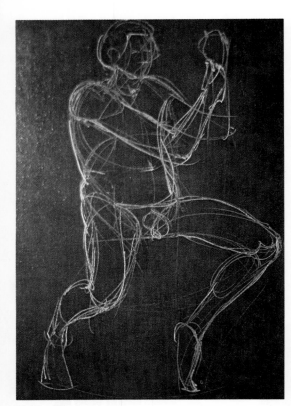

Figures 58
Examples of student class work showing the imprimatura at various stages and with varying amounts of paint applied.

a
Outline scratched into wet Umber tone with brush handle or drawn with the rubber eraser at end of a pencil.

Figure 58a

Figure 58b

b, c, d, e
Completed imprimaturas.

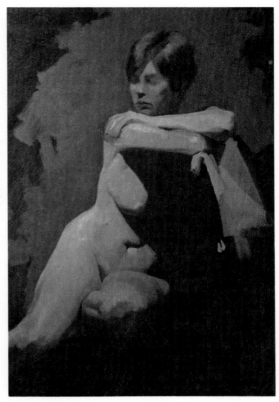

Figure 58d

Figure 58c

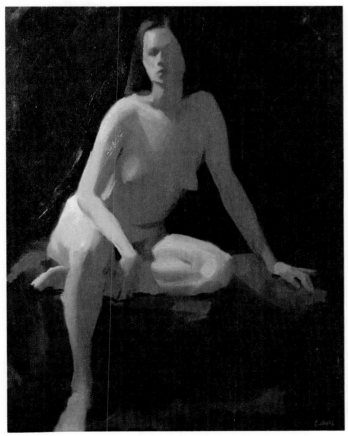

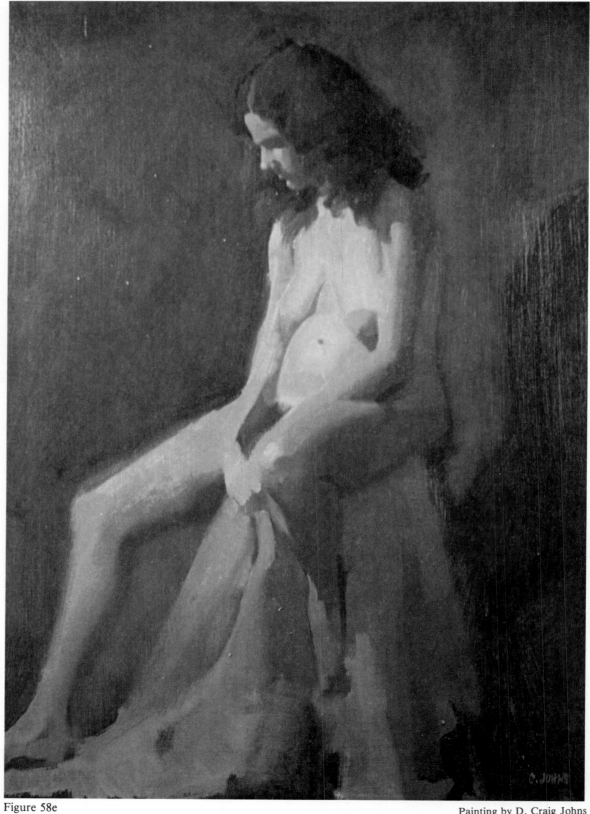

Figure 58e

Painting by D. Craig Johns

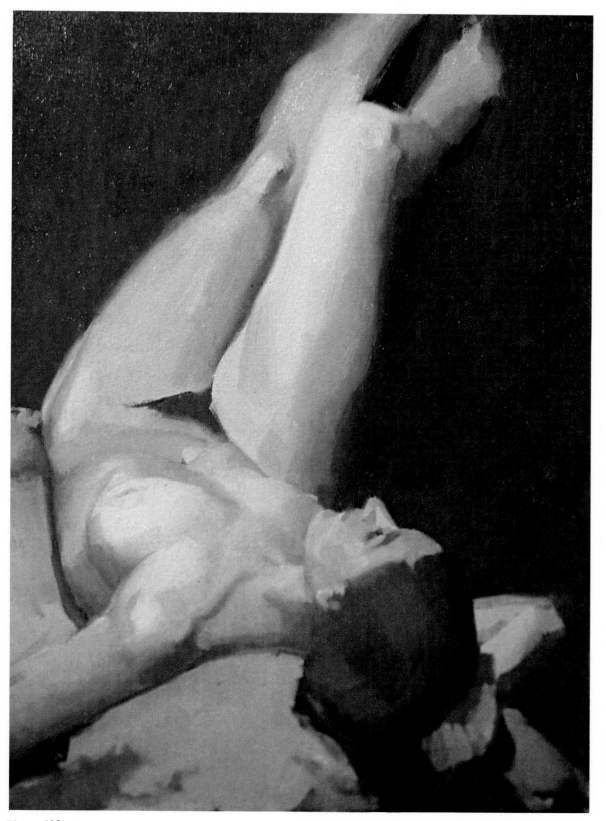

Figure 58f

Painting by D. Craig Johns

CHAPTER 12
Materials

Most books on art have a section explaining the use of the artist's materials. For that reason I will not dwell long on the subject. Here are a few points not generally covered that you may find helpful.

Brushes

Brushes are a primary concern to artists although you would never know it by looking at some of the brushes students use. How anyone expects to paint anything with stiff, scraggly instruments is beyond me. Would a carpenter use a saw without teeth, or a chisel with a dull pitted edge to make a fine piece of furniture? The brush should be capable of expressing the artist's every nuance and wish. He should control it, not the other way around.

The artist who paints in oil uses basically two kinds of brushes, bristle and sable. The variety available is enormous and quite wonderful. You can readily find a brush to suit any type of painting you wish to do.

Bristle brushes are the most commonly used in oil painting. They can carry a large amount of paint from the palette to the canvas and lay it on effectively. Sables are generally used for finishing, refining and for smaller works. Sables do not lay the paint on as successfully as bristles do, especially on a textured or rough surface.

Bristle brushes come in many sizes and shapes. There are short flat ones called "Brights" which are generally used for laying in large areas of paint and for where a square touch is desired. There are oval shaped ones called "Filberts" which lay the paint on heavily and leave a slightly soft edge. There are brushes that look like filberts but are flatter and more square tipped called "Flats". These are the most commonly and widely used ones these days. They allow for a more precise laying on of the paint. They also leave a harder edge than the filbert — this is what many modern painters want — a definite statement which they can leave or brush together as they see fit.

Finally, we have the "Rounds". Extensively used in the past they have dropped from favor, although they seem to be enjoying somewhat of a revival. Rounds leave no edges and therefore are suitable for smooth rounded forms. They are useful for certain areas of landscape painting and seascapes.

Good bristle brushes are hard to come by although at this writing the quality has vastly improved over what was generally available. Prior to World War II we had great bristle brushes such as the Mussini and Rubens. These brushes were made in Europe by skilled craftsmen who were in the trade for many years. The bristle, I am told, came from a certain breed of hog in China that was all but annihilated during the war. I am still using some brushes that are over forty years old and they work beautifully; the bristles curve nicely towards the center while painting and even after washing and drying, as a well made brush should.

The best bristles are strong and durable and at the same time have just the right amount of flexibility. If they are either too soft or too stiff they aren't any good for our purposes. The better bristles also come to a taper and are split at the ends. This enables them to pick up the paint and lay it down cleanly on the canvas. When you press down on the brush the bristles spread out and when you let up the brush should snap back towards its original shape. This allows the skillful artist maximum control of his brushwork.

The lesser quality bristle brushes have bristles with blunt ends, the bristles are not split at the ends, do not taper, are rigid and don't curve towards the center. This means you have less control of what you are doing and the results can appear crude.

Manufacturers often add starch or some sort of weak glue to keep all the bristles together and nicely shaped. Unfortunately, as soon as you dip some of these brushes in turpentine the "glue" dissolves and the bristles go off in all directions. The bristles behave like wet noodles. Such brushes are totally unfit for painting in oils.

Stay with a good brand name when purchasing a brush. Check the ferrule first, make sure it doesn't wiggle. Tug on the bristles of the brush, make sure they are securely set into the ferrule. Make certain the bristles curve towards the center. Check the spring of the brush in the palm of your hand. It should be firm but not stiff. The bristles should glide on the palm, not grate on it.

I suggest you start with a collection of "Flats". As

Figure 59a

Left to right: A wide flat bristle for pulling the freshly applied tones of paint together, both within the form and on the outside edges of the form. It should always be used clean, dry, and free of paint. Next follows a series of bristle brushes of various sizes of Brights and Flats. These are for general painting. They are best to use when drawing with the paint - that is, for long strokes. The third brush from the right is a small, short, stiff Bright. I use it for

drawing in my subject as it does not spread out and holds its chisel edge. It is also useful in painting small planes. The last two brushes shown on the right are flat sables. The small one is excellent for fine details and small planes. I prefer the sables to be of the longer variety, not the short stubby kind. Short ones are just about useless to me. The larger flat sable (extreme right) is one of the better types of brushes for brushing together the outside edges, especially on a smooth surface.

soon as you are able to you should start adding some "Brights", "Filberts" and a couple of "Rounds". You will find that each one has its own use and each will help you learn a different aspect of painting, something that would not occur to you if you used the same brush all the time.

Do not throw away a brush that you think has had it. Brushes wear down differently and acquire different shapes. Sometimes one wears down to a shape that is particularly suitable to drawing on the canvas, or for painting such things as hair. Old ones can often be converted to a fan-like brush used for landscape painting. With flat pliers squeeze the ferrule at the juncture where the bristles start. This will fan out the bristles. Then with the pliers bend one side of the ferrule towards you and the other side of the ferrule away from you. This creates a sort of twisted fan brush which is useful in the painting of foliage. See figure 59b.

Sables for oil painting come in the same shapes as the bristle brushes. They are used mainly for finishing and for fine details, and when painting on panels or a fine-grained canvas where a smooth finish is desired.

There is no way you can have a good red sable brush for a cheap price. The best brushes are made from Kolinsky Tails and are expensive. There is no way around it. When purchasing a sable brush, pull at the hairs, see if the ferrule wiggles. If anything is loose don't buy it. Check for "spring" in the hairs. Sable brushes that don't have any spring are unfit for use in painting with oils, temperas or caseins.

A good round sable brush must also come to a point when you wet it and snap it. Some art supply stores have a little jar of water available for you to make such a test. If the hairs do not snap to a point do not buy it.

Round sables are excellent to use when a "drawing technique" is desired with oil paint. They are fine for drawing in such accents and details as the eyelashes and eyelids, nostrils and the line that separates the lips. In landscape they are used extensively to paint grass, twigs and other small details. Forms modeled with round sables are smoother and rounder than forms modeled with square flat sables.

The square flat sables lay on the paint in broader

Figure 59b

On the left is a large cutter brush, used primarily when making an imprimatura. It is fine for "dusting down" the values, pulling the tones together, and softening edges. It is always used dry and clean. It should never be dipped into paint or medium. The second brush is a sable fan brush, these also come in bristle form. They are used to pull the tones together within a portrait, figure or drapery while the paint is wet. It makes for smooth modeling and subtle transitions. Its use is essential in some techniques; some artists absolutely despise them. The next four brushes are sables, both flat and round. They are usually used for fine details or modeling smooth forms. The odd shaped brush is one you make with your old brushes and a pair of pliers. It is used extensively to paint landscape foilage. The last brush is a "Bright" bristle. These type brushes are useful in laying in large areas of paint broadly and quickly.

areas. The planes can be established quickly. The tones are fused in the same manner as with flat bristle brushes. The overall effect is one of more solid planes both in the treatment of flesh and drapery. The smaller, square flat sables work almost the same as the round sables. It is up to the individual artist to decide which type of brush best suits him.

Palette-Knives

The next "tool" you should concern yourself with is the palette knife. The palette knife I am referring to is to mix your tones with on the palette, not to paint with. There is an almost bewildering assortment of sizes and shapes on the market today. The best ones are made of fine flexible steel. I prefer the one piece kind, that is where the shaft and blade are made from one piece of metal. Some are spot welded where the flat triangular part meets the shaft — these will break more rapidly than the one piece kind. You will have to test the flexibility of the blade to see if it suits you. I prefer one that is not too hard or too soft. If the blade is too narrow or short it will not pick up enough paint as you do your mixing. If it is too wide it will be too cumbersome, or stiff and better suited for cement trowel work.

The tip of the blade must not have any bends or wrinkles in it. This implies that the knife was dropped and damaged and makes it unsuitable for the mixing of paint. After long use one side of the palette knife, depending on whether you are right or left handed, will develop a concavity. It is difficult to use the knife for mixing when this happens.

The handle of the knife should fit comfortably in the palm of your hand. The ends of some handles can scratch or irritate your palm as you're mixing paint. Don't hesitate to sandpaper the end of a palette knife handle — or saw it short. Alter it to suit your hand. It has always amazed me how little tools, appliances, and other objects that are meant to be held do not really conform to the hand.

The Palette

Your palette, used to hold and mix your paint, should be of concern. Figures 45a to e in Chapter Seven shows both wooden and glass palettes.

The palette can be of any size that is convenient for your working habits. The standard 14″ by 20″ or 16″ by 20″ size is quite sufficient. I prefer a large glass palette for studio work. It is easy to work on and easy to clean. Many artists have come to this same conclusion. The glass should be heavy plate glass, not window pane glass. It should be backed with a piece of plywood or Masonite that is painted a middle grey. In this manner both the lights and the darks, as well as the weak and strong chromas, are easily visible. Ordinary clips can be used to hold the backing together with the glass. After the clips are attached, take off the handles merely by squeezing them together. A glass palette for landscape painting can also be made to fit your paint box.

A wooden palette is convenient for the artist who wishes to work close or far from his painting; or, if he is working on a large canvas where he will have to climb up and down scaffolds constantly. In such cases it is easier and more sensible to carry the traditional wooden palette.

The wooden palette should be frequently rubbed with oil so that its surface becomes smooth and non-absorbent. This is the only way it will be easy to clean. If it is not treated in this manner your paint will soak into it and be very difficult to remove and you will run the risk of gouging the wood out along with the paint. If you use a wooden palette it should be cleaned after every painting session and rubbed clean with a rag containing oil and turpentine or just oil.

The small palette cups one sees all the time are suited only for oil or mediums as far as far as I'm concerned. They are too small to adequately clean a brush. I prefer a large jar, or a can with a screen at the bottom to clean brushes. In this way you can clean your brush properly, avoiding the muddy residue that will accumulate in the small palette cup. Such residue eventually sticks to your brush and ends up on your canvas.

CHAPTER 13
Vehicles and Mediums

A medium or vehicle is *anything* that is added to paint from the tube, or ground dry pigments, to alter its quality and properties.

Students are always searching for a "Magic Medium", a medium that will make their painting superior to their fellow students or make their paintings look like the Old Masters. Of course, it never works. If you don't know anything about drawing, hue, value, chroma, edges, planes, etc. you will never do a great painting no matter how fantastic you think your medium is. Because the superior artist is knowledgeable of his craft and knows, more or less what his ends are to be, it is easier for him to utilize his materials to these ends. By getting involved with mediums at an early stage a student actually hinders his learning process.

Masterpieces can be painted with tubed paints and a little knowledge of only three or four different liquids. These are, Linseed Oil, Gum Turpentine, Damar Retouch Varnish and Oil of Cloves. Later I will talk about other oils and varnishes which alter the look and quality of the picture surface.

The linseed oil mixed with gum turpentine serves as a medium for the imprimatura and as a general painting vehicle as well as a brush cleaner.

The gum turpentine is needed occassionally to thin the paint consistency so it spreads easier and quickly over large areas. A large amount of the turpentine in relationship to the pigment will give a matte, dull effect — sometimes desirable in underpainting. There is however, danger of cracking and peeling. Too much linseed oil will give a distasteful shiny appearance. It will also yellow excessively with age.

If certain colors dry matte, and they will, a short spray of Damar Retouch Varnish will restore them to their original appearance. When the painting is completed it should be given a thin spray coat of the retouch varnish and put in a high, dust free place to dry. A final coat of varnish should not be put on until at least a year after the painting has been completed.

Oil of Cloves, the same oil your dentist uses, can be added in small amounts to your colors to keep them wet for a longer than normal time. In this way you may work for some length on a painting and still maintain a fresh "Alla Prima" look. Oil of Cloves, although dark, does not yellow perceptively.

There are many fine books which deal solely with mediums so I will not dwell long on the subject. Here, briefly, are some commonly used materials to give you a general knowledge of mediums and vehicles.

Remember, that anything you put in the paint as it comes from the tube will alter its appearance. If you add varnishes it will become glossy and slick. If you add waxes it will appear, flat and matte. Whatever the appearance of the material you add to the paint, that is what the paint will end up looking like.

You will soon learn that everytime you think you've gained something by adding an extra ingredient to your paint you will be also losing something. For instance, varnishes can provide a rich surface but also cause the paint to get too sticky and prevent proper brushwork. Oils, which produce smooth blending also create sleazy looking characterless surfaces. Then there is always the danger of uneven yellowing and cracking.

From a single substance the artist starts making mixtures. From here on in it is one mixture after another. Eventually, the artist discovers a mixture he likes and feels that he has the perfect one. Soon, however, his skills and outlook change and his medium is no longer viable. He must then evolve a new one.

The point is this: 1 — there is no such thing as a perfect medium; 2 — one artist's medium is not suited to another's abilities or technique; 3 — what constitutes a "good" medium at one stage of your development is no longer valid at another stage, and, 4 — a vast majority of the world's great artists eventually came to rely on pure oil paint alone. Most likely this was because the older they got the more knowledgeable they became. It is this knowledge plus sound technique, plus imagination that will produce great paintings.

As for the "Secret" mediums of the Old Masters, there were none. If there were such a medium all the paintings of the past centuries would be masterpieces. They aren't, and in fact some are pretty bad both artistically and technically. Generally, the better artist produced the better painting. Surely, there have been many masterpieces painted since the time of the Old

Masters and they have been painted by artists from all over the world using many different techniques.

It is my contention that technically any Old Master painting could be duplicated today (and many have), with presently available materials. If aging is required a painting can always be baked, very much like a loaf of bread in an oven.

Don't forget also that the only white the Old Masters had was white lead. Lead pigment becomes translucent in time. Couple this with the general yellowing of the pigments, the darkening of others, the constant cleaning and revarnishing of the canvas and you have the "look" of an Old Master.

Now let's talk about the oils and varnishes in common use today. All oils yellow whether they are bleached or not, so a bleached oil will yellow sooner or later just as any other oil. Do not be misled by the label on some tubes of paint which say "non-yellowing white". In time and under certain conditions they will yellow. In painting you are confronted with a choice — do you want white paint that yellows less but is sleazy to handle and has no covering power? Or, do you want a white paint that yellows slightly but is heavier and more opaque? Make your decision carefully. Most of the whites I have ever bought had too much oil in them to suit me. I always drained the oil out by placing the paint on paper towels as previously described.

Oils

Poppy Oil yellows little and gives a buttery consistency to tubed paints. It was quite popular in America in the 1920's and 1930's. A number of whites are ground in poppy oil. Many artists who paint delicate flower tints prefer to use a medium made with poppy oil. However, poppy oil becomes sticky and gummy more readily than other oils when exposed to air.

Linseed oil is the strongest and best all-around oil to use. When used to mix with pigments the cold- pressed variety is the best. Linseed oil has been used in oil painting for centuries. Van Dyke has been quoted as saying linseed oil is the best to use although he didn't specify in what manner.

There are records of the past which tell of boiling linseed oil with litharge, (a form of white lead), Verdigris and or dozens of other ingredients to improve its working ability and drying quality. The result was then mixed with mastic varnish or turpentine or beeswax and then added to the dry pigment. Probably every combination you can imagine was tried at one time or another.

Many painting disasters have resulted from these experiments and it is best for the student to stay away from them. There is even danger of lead poisoning and fire or explosions that occur while boiling these ingredients. Make sure you are thoroughly informed if you decide to make any of these mediums.

If you need a drying oil it is best to mix a drop of "Cobalt Dryer" to linseed oil or a linseed oil and turpentine mixture. This should be in the ratio of 1 drop of cobalt dryer to about 30 drops of oil or the oil and turpentine mixture.

The term "fat" applied to paint means it contains a lot of oil. Oils that are thicker and stickier than poppy or linseed oil are said to be "fatty". Such oils are sun-thickened linseed oil and stand oil. These oils are used mostly in combination with other oils, solvents and or varnishes to create mediums. They produce a more enameled surface quality than linseed or poppy oil. They also allow for a smoother transition of tones and the prevention of the spreading of the oil paint as when drawing fine lines.

Sun-thickened oil is merely linseed oil that is or was allowed to thicken in the sun. Centuries ago this was done in lead lined containers or with lead pigments so that the lead could be incorporated into the oil. This allowed the oil to lock the pigment particles together better and make the oil dry quicker with less stickiness. This sun-thickened oil was used mainly in Italy.

The northern climes, however, having little sunlight, resorted to boiling their linseed oil. This is called stand oil. The addition of stand oil to pigment allows it to "grab" on a slick surface. The colors stay pure and luminous when transparent. Stand oil prevents the pigment particles from moving around on the canvas thus producing permanent color. "Fatty" oils produce a more enameled surface than with linseed oil.

Venice turpentine is a thick, sticky substance. Its color varies from almost clear to a golden hue. Added to the pigments it will allow for the smoothest blending possible. It is seldom used in this manner however, as it is not compatible with certain colors. More often it is used as part of a medium with other ingredients. Venice turpentine imparts a pearly lustre to the colors and allows you to draw extremely fine details. Its disadvantages are that it is sticky and dries slowly. Also, it becomes brittle with age and darkens rapidly. Paintings made with mediums that have a large percentage of Venice turpentine in them may actually melt and run down the panel in extremely hot weather! I have had this happen to a painting of mine.

Beeswax has been used in oil paintings in some form or other all the way back to the time of the ancient Greeks. To be used in oil painting, beeswax must first be melted with linseed oil. When it cools it should be a soft paste. If not, add more linseed oil and melt it again. This paste is then added to the oil paint in various degrees depending on what effect the artist wants. One function of the beeswax, at least in times past, was to act as a binder with pigments much the same way aluminum stearate is used today. The wax, imparts a translucency to the colors and allows for thick impastos, mainly used in the light areas. As it dries matte, however, it destroys the richness of the deep, dark colors.

It's strange in this age of science and chemistry that the leading authorities on the art materials disagree as to whether the Old Masters used wax with their pigments or not. In any case, as we know, these things are not necessary for the creation of a masterpiece.

Varnishes

The most important, widely used varnishes are Damar, Mastic, Copal and Amber. There are many synthetic varnishes, but since they have not been time tested in the use of oil painting it is best to stay away from them.

A thin coat of Damar Retouch Varnish is generally considered to be the safest varnish to put over a painting. Full strength Damar should not be applied to a painting unless it is at least a year or two old. The surface being cleaned before applying.

Varnishing should never be done on a day that is damp or cold as the varnish will not adhere well to the surface of the painting. Humidity trapped in and between the varnish and the painting will cause "blooming" which is an offensive, whitish, irregulat spot or shape. It is likely to cause cracking later.

Mastic is a golden hued varnish often used by the Old Masters. Goya is known to have coated his entire canvas with Mastic varnish when doing retouching over his basically alla-prima paintings. Its outstanding ability is supposed to be its elasticity — it'll expand and contract with temperature changes without cracking. I once used Mastic and I liked the richness it gave to the colors, however it was sticky and took too long to dry. The stickiness collected dust and lint on the surface — it acted much like fly paper. Since the objectives of the varnish is to seal the painting from dust and dirt it's hard to see how Mastic varnish helps.

Copal and Amber varnishes are dark, rich, and extremely hard and durable. They dry fast and hard to the touch, not sticky. Amber seems to be vanishing from the market while Copal is ascending. Both varnishes are dark and should be highly diluted with turpentine or alcohol if they are to be used with delicate tints of color or for isolating layers of a painting.

Many artists use a mixture of Copal Varnish and stand oil. This imparts a lustrous, rich, glossy surface to the painting. It dries hard, fast and permanent. This mixture supposedly "locks in" the colors. The combinations of the above named ingredients are innumerable and I'm sure the curious artist will experiment with these mixtures whether I suggest it or not. Additives should be used sparingly. Paint should be the major part of a painting. Mediums should be used only to achieve effects when they cannot be created by any means other than ordinary paint. The beauty of a painting comes from painting, not from secondary effects.

As I have previously pointed out, what you know and what you feel is what will enable you to create a fine painting. Many artists, both student and otherwise become hopelessly enmeshed in the chemistry of paint much to the detriment of their work. Mediums can definitely hinder a beginner. Remember, there is no "secret" chemical formula that can save a poor painting.

CHAPTER 14
The "Lay-In" and Massing of the Tones

The first indications of paint that are applied to the canvas are called an "Ebauche" in French and "Abozzo" in Italian. These terms simply indicate the first touches or outlines put upon the canvas. They should not be confused with the term "lay-in" as it applies to this system of painting. True, the "lay-in" is the first opaque layer of paint, but it is of definite tones in definite places. The lay-in requires an averaging of values to be properly accomplished. Such averaging is called "massing", therefore, the term is usually used as "lay-in and massing".

Because of the many factors of painting not adequately understood by the beginner, laying in and massing is difficult to write about. It would be difficult enough even if we were all in a studio with the model in front of us.

To begin with it is essential that you know how to see values and planes. You must know how to mix the correct tones to match the subject matter; be able to supply these tones on the proper planes and fuse them with the proper edges. Finally, you must be able to make decisions regarding these factors based on certain concepts. We'll now discuss these concepts.

Almost all the great realistic painters, past and present, work from large forms to the smaller forms. A minority worked from the small to the large, but, in the end the small forms were always subordinated to the large forms. It takes longer to work from small to large and that is one of the reasons many artists rejected it.

Here is an example. If you are painting only the deltoid form of the upper arm then that is your big form. If you are painting *only* an arm then the arm is your big form and the deltoid is a subordinate form of the arm. If you are painting the upper part of the torso plus the arm then that part of the torso is the biggest form, the arm subordinated to it and the deltoid subordinated to the arm. If you are painting the entire torso then it is all to be regarded as the biggest form; the rib cage and pelvic section are smaller units to be subordinated to it and the arms and legs to be subordinated to the whole. Within the arm as well as the leg are forms which are subordinated to them. The bigger forms

should be painted first, the smaller ones next, and the smallest ones last. It is logical, then, the lay-in should be large and broadly stated. All of this applies as well to landscapes, backgrounds and drapery.

In the case of the human figure, the torso, the legs, and the arms are to be regarded as cylindrical in nature. The head is an oval.

Another thing the student should cultivate, especially when painting from life, is the concept of what is called a "one look" picture. This means, the model should be painted to look like the first quick impression the artist receives. If you stare too long into the lights you will start to see many darks. If you look too long into the shadows they will start to appear much lighter and more colorful than they actually are. When painting with this visual attitude you will lose the strong feeling of light and shade on the model. Always paint the model by looking at the area of lightest light and try to "half-see" everything else. Avoid going too dark in the light using more hue and chroma as well as crisper brushwork — paint everything subordinated to the light.

Procedure of the Lay-In and Massing

First determine what lighting situation the model is in. Remember, there are only four basic lighting situations, Front, Form, Rim, and Back. Each one of these has its own light and shade value scale as was previously explained in Chapter 6. Let us assume the model is in Form Lighting. Looking at the Form Lighting Scale on page **36** we see that the light side extends from White, (10) to the fourth value and the shadow side starts at the fourth value and goes to Black, (0). The flesh tones are then mixed to correspond to these values. You know that you must not paint anything lower than the fourth value in the light and not anything lighter than the fourth value in the shadow. The halftone values will be at the lower end of the lights.

Next observe the position of the light source. Draw an imaginary straight line from the center of the light source to the model. Where this line touches the model will be the area of lightest light. From this area it will

The following illustrations show aspects of the halftone and its treatment. Study them well. Make copies and variations of them to further understand them. Then try to find these principles in nature.

Figure 60
Here we see how the halftone plane changes when the position of the light source changes.

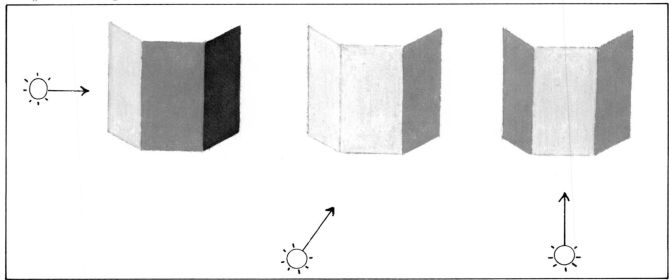

a.
The light is coming from the left side. The halftone plane is the flat plane facing you. The shadow plane is on the right, turning away from you.

b.
The light source is moved towards the front. The halftone plane now moves over to where the shadow plane was.

c.
The light source is full front and pulled back. We now have the front plane in the light. The two side planes become halftone planes.

Figure 61
How the halftones are made in paint.

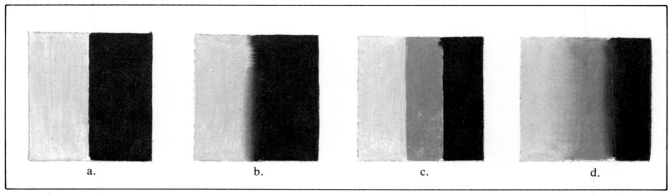

a.
If the halftone is narrow simply paint in an area of light tone and an area of shadow.

b.
Zig-zag the tones together with a flat brush. Wipe the brush clean and dry. Make a downward stroke through the zig-zag to make the halftone.

c
If the halftone band is wide then you will have to paint it in as a separate tone. Here we see a light tone, a halftone, and a shadow.

d.
First zig-zag the light into the halftone. Next zig-zag the halftone into the shadow. With a clean, dry brush stroke down these zig-zag effects to fuse the tones.

Figure 62
These three examples show the different stages of the laying in and fusing the tones. When properly done all forms can be painted in this manner.

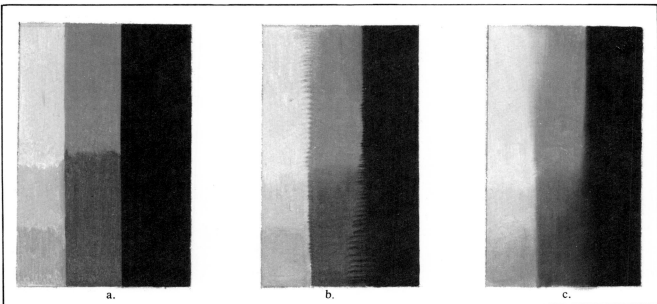

a.

b.

c.

a.
Here are three basic tones: a light tone, a halftone, and a shadow. The light tone has three divisions. The halftone has two divisions, one representing the light halftone, the other representing the dark halftone. The shadow masses usually as a single tone.

b.
The tones are zig-zagged together — to a greater degree where they mass and to a lesser degree where they stay more distinct.
c.
The tones are brushed together with a wide, clean, dry brush. Try to capture every subtle variation of the way the planes fuse with each other. Do not overwork it.

radiate in *all* directions while becoming progressively darkest in value. The shadow plane will be at right angles to the line from the light source. The gradations of light will overlap many forms and planes. It is the *large* areas of light, halftone and shadow that are painted in first.

Disregard — and this is easier said than done — the darks you see in the light area and the lights you see in the dark area. Squint your eyes and average out the lights, the halftone plane, and the shadow plane. Paint these three planes in boldly, starting with the shadow plane first as it is the most obvious. If you have a good command of values you can break up the light average into three or four different subdivisions. See Figure 18.

Most students can determine the shadow pattern and the light areas but get lost when they have to decide on where the halftone is. If your painting is muddy looking or lacks light effect it is likely your halftone is either too dark or in the wrong place or both. Simply, you are going too dark in value in the light area. To be on the safe side, especially when painting women, it is best to leave out the halftones, or make them lighter than they appear to the eye, and mass them with the lights. In many cases an arbitrary decision, based on experience, has to be made.

After the big statements are made the smaller forms are added and modeled. Make the smaller forms first by accurately placing the side, bottom and top planes. Highlights and crest lights are then added. The whole painting at this stage, especially in the light areas, should look much like a mosaic. Some artists keep on

this way, breaking up the planes into finer and finer divisions refusing to brush anything together. Others prefer to blend the tones in order to fuse the planes and then restate the lights. Both methods are excellent.

There is no known rule as to where you may find the halftone. All I can tell you is that you should look for it near the shadow plane. How wide an area it occupies and what its shape is varies with the planes of the object and the position of the light in relationship to those planes. See Figures 60, 61 and 62.

Halftones will mass in different degrees on the side where it meets the light and on the side where it meets the shadow. You will find in most cases the halftone will vary in the degree it masses with the light or shadow. For instance where the halftone meets the light it may mass completely with it in one area, mass slightly with it in another area and stay quite distinct in yet another. The same thing may occur where the halftone meets the shadow plane. You will have to refer to the model for this information. See Figures 67b, c and d. Try to find a light area, a halftone area, and a shadow area that run the entire length of the figure of whatever the subject is that you're painting. Sometimes these planes may skip large forms and therefore be elusive. Do not let this confuse you or deter you from painting them as single planes. If a form is too large such as a rib-cage then merely lift your brush and continue to lay the paint on when you pass it.

CHAPTER 15
Drapery

Drapery in painting serves many functions. One of them is purely decorative, where it can enhance or beautify the picture. The most common use of drapery is to explain the form beneath it and to show the action or direction of the movement of the figure.

The drawing of drapery is an important step in the understanding of the painting of drapery. Although, this book is concerned mostly with painting here are a few points about drawing you should keep in mind. Careful observation will show there are mostly straight lines in drapery. What appears rounded is usually made up of several straight lines. the heavier the material the more rounded the folds will look, the thinner the material the more angular the folds become. Also, look for triangular shapes. Drapery abounds with triangular shapes. Observe the points of pull of the fold. A fold is always coming from a point of tension and heading in the direction of another point of tension. Examples of these are found at the elbow, the knee, and the crotch. The point can also be at the maximum cresting of any form. The fold or drapery should show the form beneath by being painted or drawn as *going around* the form. At times, you may also have to invent values in order to portray the form beneath.

Drapery can be painted from two radically different viewpoints. One, as the light coming from it effects the eye; and, secondly, as the actual form, appealing much to the tactile sense. Think of the drapery as painted by El Greco at one extreme and the drapery of Ingres at the other extreme as examples.

The great English portrait artists such as Gainsborough, (1727-1788), Reynolds, (1723-1792), and Sir Thomas Lawrence, (1769-1830), almost always painted the drapery in their portraits from the standpoint of light producing the *illusion* of modeled forms at a distance. However, they did not do this much on the faces. Patrons probably would complain of the thick blobs of paint on their likenesses. Thus the heads are smoothly modeled while elsewhere in the picture the artist painted as he pleased. Later, Sargent, (1856-1925), successfully painted entire portraits in this manner.

Painting drapery to produce *the illusion of form* rather than modeling the actual form, was often used in large

Figure 63
Detail of drapery from portrait of Elizabeth Farren by Sir Thomas Lawrence (1769-1830).

Elizabeth Farren
Sir Thomas Lawrence
Courtesy Metropolitan Museum of Art, Bequest of Edward S. Harkness, 1940

Mrs. Grace Dalrymple
Thomas Gainsborough
Courtesy Metropolitan Museum of Art, Bequest of William K. Vanderbilt, 1920

paintings, which, of course, were meant to be viewed at a distance. The nature of the size of the canvas and the thickly applied impastos forces the observer to stand back and see the *illusion* of form in space, exactly as the artist had intended. See Figures 63 and 64.

Many years ago I first saw the portrait of Eliza Farren, Countess of Derby, by Sir Thomas Lawrence. The white cape and gown looked so smoothly modeled. It seemed that way every time I loooked at it. However, as I grew older my perceptions of colors and values increased, and one day I saw the portrait entirely different. What I thought was smoothly modeled was an illusion created by cleverly placing thick strokes of paint next to each other. See Figure 63. This technique is still used today, many artists, however, apply the same approach to the modeling of the features as well.

The other method of painting drapery, by modeling each form and fold individually, goes back to the earliest days of painting. Artists used many different techniques and procedures to achieve their goals but the end results were quite similar. This can be demonstrated by comparing the works of Jan Van Eyck to Sir Anthony Van Dyck, to the artists of the French Academy, to the super-realists of today. The drapery is painted from the standpoint of how it is known and appeals to the sense of touch, not from the standpoint of painting the illusion of light bouncing from the form.

Artists almost always render the folds when painting a small picture. One reason, of course, is people try to look at a painting with their noses — they get right up close to see every detail. Should an eyelash be missing, the painting is denounced.

The actual rendering of drapery can be simply explained and successfully accomplished with a definite procedure and a few simple rules.

It is harder to explain the light conscious approach as there is considerable leeway in execution and much depends on feeling, subjective impulses, and manual dexterity. You really have to be "up" when painting this way. It doesn't hurt to be a hyper-thyroid if you wish to paint in this manner.

Both methods will be facilitated by the mixing of four or five tones matching the tones of the drapery to be painted. You will achieve the maximum of form but the minimum of color. If more color within the drapery is desired it must be added to the applied tones *before* brushing begins. To achieve even more color, then you have to work with an open palette of many colors and paint from the standpoint of light consciousness.

In the finished painting done by a good artist the drapery usually appears deceptively simple. This is because the artist has solved many problems beforehand. What he painted was not what he was actually looking at, but, the spectator does not know this.

The first thing you see when you look at drapery is that there appears to be many dark folds in the light area and many light folds in the dark area. This is an illusion as darks surrounded by light appear darker than they are and lights surrounded by dark appear lighter than they are. If you copy them as you see them you will lose the biggest most important thing about drapery — that is, its basic form. To preserve the feeling of light and shade on the big form one should paint the darks in the light lighter than they appear and the lights in the dark, darker than they appear. Painting otherwise will produce warps, dents, or holes.

The big form and lighting gradation must be maintained regardless of how many folds and wrinkles are painted. Visualize the light, halftone and shadow on a form. Now visualize folds within these areas. You can see that the dark folds would be out of place in the light and the light folds out of place in the dark area. In addition, too many small folds have a tendency to flatten out the bigger forms. It is wiser to leave them out.

The following six steps shown in Figure 65 explain the method of rendering drapery. To reproduce the same effect in color simply mix up a row of whatever colors you wish to match the black and white values and follow the same procedure.

Figure 64
Detail of drapery from portrait of Mrs. Grace Dalrymple by Thomas Gainsborough (1727-1788).

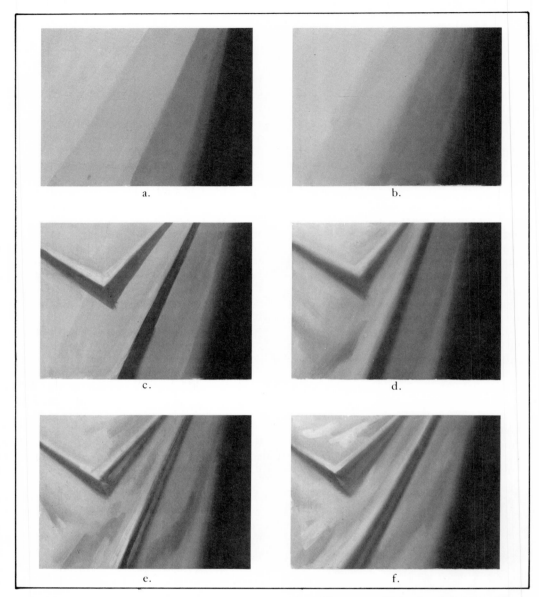

Figure 65

a.

The basic tones. These are taken from nature. Squint hard and try to ascertain where the lights, halftone and shadow divide. These tones should be of the proper value and express the direction of the light as well as the big, basic form beneath.

b.

The first blending. These tones are blended together using, preferably, a flat wide brush. This stage is not too critical unless your drapery is to remain generally flat. In that case you must be careful with your blending as some areas are massed altogether by brushing, some are only partly brushed together and some do not have to be brushed at all.

c.

Statement of folds. With a rag or a stiff dry brush wipe out the areas that are to be occupied by the folds. State the folds in simple light and shade, that is, just one light tone and one shadow tone. There is no need for the higher lights or reflected lights at this

stage. If you are sufficiently advanced in values and form you can start at this stage if you wish.

d.

The second blending. Everything is brushed together now. The brushing should not be equal all over as to the character of the drapery will be lost. A few minor lights and darks can be added in. If the drapery is to be represented as being seen at a distance, or subordinated to the model, such as being behind the model, then one could stop at this stage.

e.

Now the lighter lights, on the ridges of the folds and the reflected lights which are within the shadow area, are added. Several smaller lights and darks can be added within the tones.

f.

Final stage. The reflected lights are softened into the shadow. The lighter lights are brushed slightly into the folds. These lights, as well as other strong lights are restated boldly with heavy impastos and left untouched.

Figure 66
Details of drapery from a series of illustrations by the author. In this style of painting the actual form of the folds and drapery are painted - in contrast to the technique of producing the illusion of the drapery forms by the clever placement of tones and edges.

Figure 66a

Figure 66b

Figure 66c

Figure 66d

Figure 66e

Figure 66f

Figure 66g

CHAPTER 16
Generalizations Concerning the Complexion

Before we go on to the subjects of painting the head and the torso I would like to mention some generalizations concerning them. These are obvious to the eye but are frequently overlooked.

Most beginners are usually concerned with the little things, whereas, the more advanced artist concerns himself with the larger, broader aspects of the picture.

A person's "average" completion is found in the torso — the midsection, from below the pit of the neck to above the crotch. Towards the extremities, that is the head, arms and hands and legs and feet, the average becomes darker in value. In a white person the complexion also becomes stronger in chroma and redder at the extremities. The reason is that these parts of the body are more exposed to the elements; the double passage of blood is more noticeable and there is an increase of smaller forms which break up the larger effect of light.

In regards to the head, we divide it into three bands. The upper band is the forehead, the middle band extends from the brow to the bottom of the nose, and the lowest band goes from the bottom of the nose to the bottom of the chin.

The forehead is to be taken as the "average" for the complexion of the face. The middle band is *darker in value* than the forehead band and the lower band is still darker, especially in the male.

The middle band is *redder* than the forehead, in the cheeks, the nose and the ears. The lower band goes back to its natural hue.

The middle band is *stronger in chroma* than the forehead. The lower band is weaker in chroma than the average. Again, this is most noticeable in the male.

Once the larger statements are made then you put in the smaller local hue, value, and chroma changes. These occur within the big generalizations. Examples are the reddishness of the chest, the reddening of the nipples of the breast and the coloration or discoloration unique to the subjects knees, ankles, buttocks, or any other part of the body.

This information is mainly for painting from the model indoors. There are exceptions, for example, in portraiture or for the sake of composition where you may not want to follow nature.

When doing a portrait, especially of a woman, it is best not to darken the lower part of the face too much, nor is it advisable to give her a red nose or paint her hands too red. Such conditions, while they may be true may be distasteful to the sitter. You should be guided by what the sitter desires tempered by your own taste and judgement.

When painting a male the reverse seems to be true. The overstatement of the hues, values and chromas may add to the character and definition of the portrait.

Side planes, which our vision tends to skip over, appear greyer and darker than the front planes. A large part of this is due to small body hairs seen in perspective. As a result we see a diffusion of hair and skin and less of the true skin color.

Youthfulness of flesh can best be obtained by making the edges redder. Although this is a stylization in most instances it was probably arrived at by observing that the more youthful flesh is the more translucent it is; that is, light will enter it at one angle, penetrate it partially, and emerge at the opposite side. Where this happens the skin appears stronger in chroma. Wherever translucency occurs there is an increase of chroma.

Many artists resorted to using a sort of a red to outline the toes and fingers of their subjects. They would then brush their flesh tints into this red and the job was done. This works best on pictures that are mainly in the yellow-red key. With different color schemes this is no longer valid.

CHAPTER 17
Painting the Figure

The following pages show the painting of the figure on a toned canvas in a direct manner. There wasn't any underpainting, nor were scumblings or glazes used. This is the fastest, simplest way to make a finished painting that I know of. An excellent exercise for you would be to follow the procedure shown step-by-step through to completion. Once this approach is mastered, the same procedure can be used on anything else you wish to paint.

This method, however, is deceiving in its simplicity and should not be attempted unless you have made many imprimaturas and have a fairly good comprehension of all that has been covered in the previous chapters. It is through the imprimatura especially, that the values of the tones and the decision of where these tones should be placed is arrived at. If you are in doubt or unsure of yourself use the imprimatura as your first step. When you are sufficiently advanced you may do away with it and proceed directly onto the toned canvas as shown.

Figure 67 is a schematic drawing showing where the major tonal masses are to be placed. This drawing is necessary for the sake of clarity and explanation. If your eye is not sufficiently trained to see the difference of the flesh tones in the following examples simply refer to this linear conception.

Figure 67a shows a simplified chalk drawing over a toned canvas. This tone may be transparent or opaque, warm or cool. It depends on your viewpoint. Within the figure only the shadow pattern need be designated.

Figure 67b. Here the large massed value patterns are layed-in in monochrome. This is arrived at by averaging the values, ending them where the form takes a definite bend or turn. This step is crucial and the success or failure of the finish is usually decided at this point.

The darkest darks, that is, the accents are put in at this stage. The accent is black with the addition of Alizarin Crimson or a deep red to warm it up. Do not be afraid to apply it boldly. When it is brushed together with the skin tones it won't appear so jarring.

Figure 67c. Hue and chroma changes are now added to the specific planes of monochrome paint. These ''color'' changes are to be the same value as the planes they are painted onto. Note how the arms and hand get redder, as well as the lower lights and halftones of the buttocks and

leg. Note also, the greying of the side planes of the buttocks, leg and upper left shoulder.

Figure 67d. The darker underplanes of the shadow area are now added, creating the illusion of light within the shadow. All the basic tones are now blended. The procedure of blending paint is described in the chapter on edges. Examples of this procedure are deliberately shown on the upper right arm and on the left leg. Think out in advance where your blending is to be and of what degree. The tones are to be blended only to the degree they appear to the eye. You will observe some tones blend completely together while others stay quite distinct from each other. A fan brush may have to be used at times for the more delicate transitions.

After this blending is accomplished, step back and see if you have the correct value patterns and the proper complexion of the objects.

Figure 67e. In this step the big forms are developed further. Here we add top planes, bottom planes, center lighting and highlights. The lights are added with a ''loaded'' brush. It is a good idea to put the paint on heavier and heavier the lighter you go — the highlight being the heaviest bit of paint. Take care that the darks do not ''punch holes'' within the area that they have been placed. The lights, however, can be added a little lighter than they appear as they will be reduced somewhat in future brushing.

The hue of the reflected light (in this case yellow-red) is now added and blended into the shadow area. In the painting of a male figure, I would be inclined to stop near this stage.

Figure 67f. The final stage with everything properly brushed together. The top planes and highlights are brushed less than the side or bottom planes.

The outside edges are now taken care of. Note the hardest edge near the lightest light on the hip, grading into a softer edge as it goes both up and down. The softest edges are around the hair and where the shadow side of the arm approaches the same value as the background.

Care must be taken with these edges. If a mistake is made you will have to restate the paint and try again.

If all goes well, a painting such as this can be finished in one sitting. This one was.

Figure 67
*A schematic drawing showing the general placement of the major
flesh tones. "A" is the largest area of the lightest light. "A₁" is a
slightly darker area. "B", "C" and "D" are the large areas of
the darker lights. "E" is a halftone band. "F" is the shadow.
"F₁" is the reflected light and "G" is the darkest dark, an
accent.*

Figure 67 a. b. c. d. e. f.
Six basic steps in painting the figure. The tones are deliberately
overstated for the sake of clarity.

Figure **67a** - Step one

Figure 67b - Step two

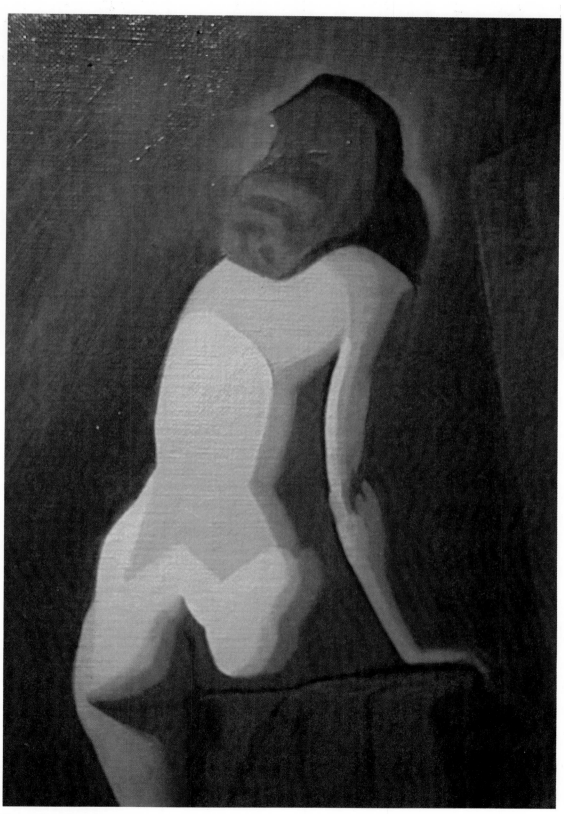

Figure 67c - Step three

Figure 67d Step four

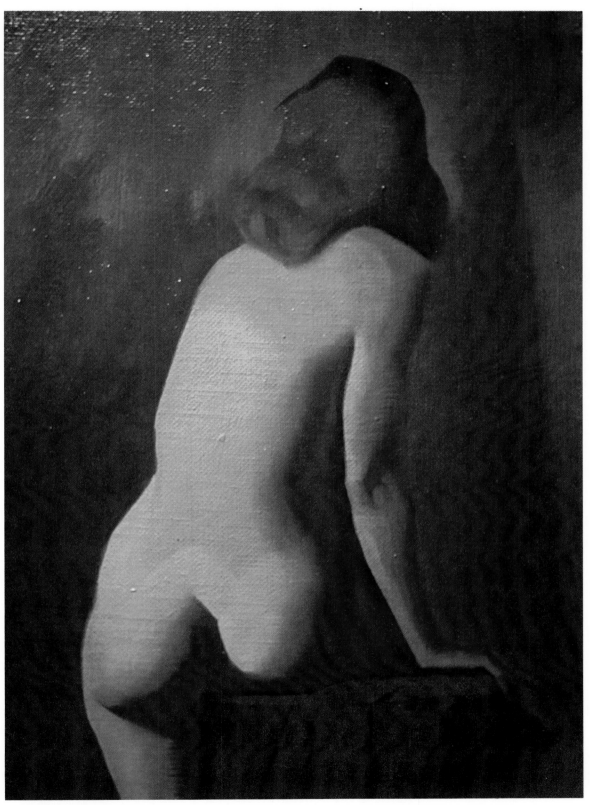

Figure 67e - Step five

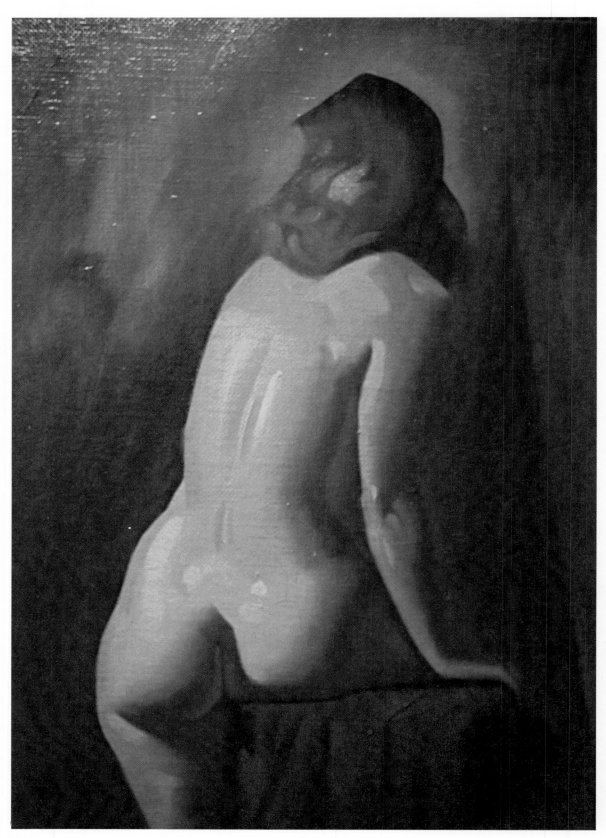

Figure 67f - Step six

Finished Painting

CHAPTER 18
Painting the Portrait

The following series of illustrations show the painting of the head as I teach it at the Art Student's League of New York. The painting of the head should not be attempted unless you have a good foundation in drawing and fully understood the earlier chapters. The method is based on the best qualities of all the good, realistic schools of painting throughout the ages. This is not the only way to paint a portrait, every artist will decide that for himself. However, if you haven't done much painting or if you find yourself in difficulty when painting a portrait, then this step by step approach should be of help.

Here there is no heavy, opaque, underpainting covered by a series of overpaintings. There is no glazing, no scumbling. No magic "Old Master" medium is used, nor exotic varnishes with "other ingredients". Such technical additions will be left up to you, to do as you see fit, to express your feelings about the way your paintings should look.

What you paint with are good brushes, a good brand of paint, linseed oil, gum turpentine, oil of cloves and an optional few drops of Cobalt Dryer. The canvas you use is a double-primed cotton or linen. When you are finished you will spray the entire surface with a thin layer of Damar Retouch Varnish and let it dry in a dust free area.

The method is fast, permanent and will not yellow to any perceptable degree. I have paintings that I have finished in this manner over twenty-five years ago and they have not yellowed, faded or cracked as yet.

The use of the imprimatura, (Chapter 11), is one of the best ways to start a portrait or a figure when working from life. Drawing, values, edges and placement are more easily accomplished than by any other method. Moreover, this beautifully modulated wash of Umber dries overnight and allows for quick overpainting. It does not interfere with the paint and brushwork you'll put on. And some areas will be allowed to show through as part of the final painting.

If you feel unsure about drawing within the imprimatura or if you are doing a mural or a complex painting, then you can do an actual size drawing of the subject, called a "Cartoon". The cartoon is transferred to the canvas, panel or wall by the "squaring off" method or by tracing with chalk or pencil. This drawing is then gone over with a diluted india ink using a round sable brush. The brown tone is then applied to the canvas. If the ink is diluted too much you will not see the line through this brown tone. If the ink is too dark the line will pop up in the light areas and destroy the subtle modeling.

I have used this method in this instance because I photographed the entire procedure step-by-step. I had to proceed in a certain order making as few mistakes and corrections as possible. I had only one chance. If things went wrong in the later stages I would have had to start all over again. Generally, when working from life it is best to proceed without the rigid outline. The fluid medium allows for slight and subtle changes, as well as a nicer range of values and edges which produces an aesthetically superior product.

The following text and illustrations, Figure 68 a to k, describe how I made the imprimatura that was used as an underpainting for this full color portrait.

A brown tone (b), made of Raw Umber was washed over the surface, which, in this case, contained a dry brush drawing of the model. The drawing was made with diluted india ink (a). The tone was the value of the model's skin in shadow.

In the second stage the background was rubbed out to its proper value with a piece of fine cheesecloth (c). The background, in cases where there is a single source of light, is almost always lighter than the model's shadow. It is a general rule, that, all textures being similar, *anything in the light will be lighter than anything in the shadow.* This background value was also used to define the basic, big shapes of the model on the canvas. This should be pleasing to the eye, especially in regards to size and placement.

The third stage involves a "known quantity". Two examples of a known quantity are white and black. The known quantity, white, was rubbed out first. Rub down almost to the white of the canvas (e) for this effect. If there is a dark quantity, such as deep brown hair, it is stated in using plain tubed pigment *without* any oil or turpentine. Following this the darks (f) that

are darker than the background such as eyebrows, the eyelashes, the nostrils, and dark accents such as the line separating the lips and where the neck turns into the collar were stated. The overall value-pattern of the hair was kept simple as lights at this stage would be out of balance with the rest of the painting. The rest of the white blouse was completely modeled (g). When all this was finished a clean, dry cutter brush was used to delicately dust over everything to pull it together.

Fourth stage. After these known quantities were stated and dusted over the actual modeling of the head was begun. Don't forget we already have the shadow tone. At this point there are two ways to proceed. I used the method described below.

After studying the light and shade on the model I mentally removed the top planes, the highlights, the crest lights and the underplanes. I was then left with the large areas of light averages of skin tone. Next I rubbed out the area of the lightest light average — note it is lower in value than white. From this area of light I gradually worked my way downwards and sidewards to the areas of the lower light averages (h). At this point, everything was dusted together with the dry cutter brush. Halftones were made by dry brushing from the shadow side into the low light average (j). Now the shadow may have to be restated as it might lighten up in the process. Top planes were then added by rubbing out the remaining tone with cheesecloth (k). You will find that in this process when you form top planes on top of your average, the average looks a little darker than before. It is wise not to state darker underplanes before this stage. Crest lights were added to model the form but highlights were not necessary as the whole area was going to be covered with broad masses of paint. You may add highlights, however, if you are making studies or if you intend to match every piece of the imprimatura with a corresponding piece of paint.

Fifth stage. At this point I stepped back to get an overall view of what I had done as the imprimatura was almost finished (k). I made sure the flat value-patterns were not overly modeled — that is, the lights and darks on the background, the face, the hair, etc. did not jump out too much or "punch holes" in the canvas. I made adjustments then and dusted it all together again paying particular attention to where the soft edges were to be.

The other way is to proceed as follows. Do everything the same up to the end of the third stage; now, rub out *everything* of the tone of the face which *is not* shadow to an overall average. Check this value pattern with the value pattern of everything else in your picture such as the background, the hair, the shirt, etc. Now rub out the area of lightest light within this pattern, and by degrees, rub out the lesser lights, modeling your forms as you go until you can't model any more. Again the halftones are made by dusting from the shadow side into the light area. Everything else is dusted down with a clean dry brush as before. The top lights and crest lights are modeled now — darks restated, accents added, planes refined. Perhaps an underplane should be added. If you desire a greater than normal light effect then dust the tones together delicately and keep modeling lighter in the lights.

Figure 68k shows the finished imprimatura. The one that will be painted over.

Figure 69 shows the palette with the mixed flesh tones we will use. Note the black and the red mixed with the white on the left. These are the greying areas or altering complexion tones. Viridian can also be used successfully in this manner. Oil of Cloves has been added to all of the paint in order to keep it workable for a week or two. The Oil of Cloves merely has to be dropped on the paint, it will mix itself into the paint overnight by capillary action. By keeping the paint wet you will be able to blend tones and edges nicely without the interference of sticky or tacky paint. You will also be able to make many additions and changes that may occur as after thoughts without losing the overall unity of the painting.

Figure 68

Note: The shine evident in some areas of the steps of this painting were caused by reflection of the photographic lights on the wet paint. The photographs were taken as the picture was being painted making it extremely difficult to assure flat lighting.

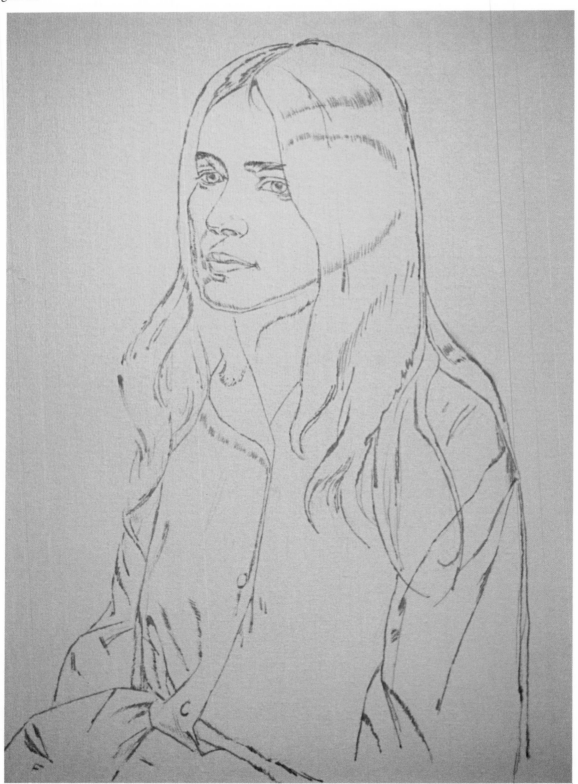

Figure 68a
A dry brush drawing made with diluted india ink over a pencil drawing over a white canvas.

Figure 68b
A tone of umber being applied over the canvas using oil and gum turpentine as a medium. It should be about the same value of the model's skin.

Figure 68c
The canvas is now completely covered with the umber tone.

Figure 68d
The value of the background, which is lighter than the model's shadow is now obtained by gently rubbing into the wet umber with a clean piece of cheesecloth.

Figure 68e
A known quantity, in this case the white of the blouse, is always the first thing you must obtain. White is obtained by rubbing very hard into the tone until the white canvas is showing.

Figure 68f
Other known quantities such as darks are now stated into the tone with pure umber. These include the dark hair, eyebrows, eyelashes, nostrils, accents, etc.

Figure 68g
The white blouse is fully modeled.

Figure 68h
*The large area of lightest light of the head is obtained by rubbing
into the tone. It should not be lighter than the lightest portion of
the white blouse.*

Figure 68i

Additional, lower valued lights are made by gently rubbing them out with the cheesecloth. Do Not make them lighter than your area of lightest light.

Figure 68j
The lights are subtly fused into the average tone, the shadows are restated, halftones are made by drybrushing the shadow area into the lower light areas.

Figure 68k

Final Stage. Top planes and crest lights added to the face and to the hair. Refinements are made in values, edges, planes. Everything is then dusted together with a wide, flat, drybrush. Lights may be increased a bit in value by gently rubbing into the wet tone with a piece of clean cheesecloth.

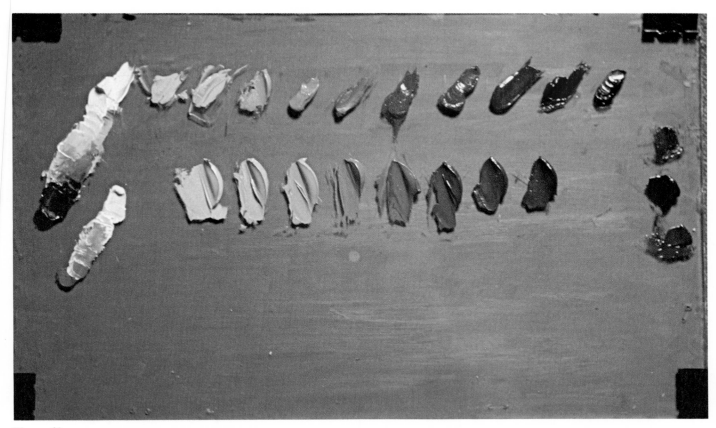

Figure 69
The palette, showing on the second line, the premixed flesh tones
for the following portrait.

Figure 70a
A close up of the imprimatura with background color.

Figure 70b
*The shadows of the skin and hair are stated. They should be
simple and massed.*

Figure 70c
The halftones are applied, adjacent to the shadow.

Figure 70d
The area of lightest light, the forehead, in this case, is boldly stated.

Figure 70e
Additional skin tones added. These lie between the values of the area of lightest light and the halftone. They can be applied with or without the addition of hue and chroma changes depending on the skill of the artist. At this stage the lips, the eyes, and the hair are still the imprimatura. It will be easier to judge the complex colors and forms of the lips and eyes when all the surrounding colors and values are in place. Since the hair in the imprimatura is almost the same color as it will be when paint is applied it isn't necessary to state it now. The accents, in the darkest parts of the shadow, the eyelashes, eyebrows and reflected lights are also painted in.

Figure 70f
These basic tones are now brushed together. Care should be taken to neither overbrush nor underbrush these tones.

Figure 70g
The colors of the eye and its surrounding flesh are stated. Follow your imprimatura carefully as there is too much of a tendency to make the white of the cornea too light. Students seldom paint the eye socket with its proper feeling of depth because they make all the lights within it too light. If you observe carefully the area of lightest light, the forehead, you will note that the eye socket and its lights are lower in value than the values above it.

Figure 70h
The shadow planes of the lips stated.

Figure 70i
Flat average of the lip color applied.

Figure 70j
Top lights added to lip color to produce form.

Figure 70k
Lips brushed into surrounding skin tones, top planes, high-lights, and hair tones added.

Figure 70l
*Top planes are brushed into skin averages. Hair tones stated
and brushed into skin.*

Figure 70m
The tones of the hair brushed together. Lightest area of blouse added.

Figure 70n
The tones of the blouse laid in. If you desire more color you can add it here.

Figure 70o
Showing the zig-zagging of the tones together. Make sure the
value of the hue is the same as the area you're working it into.

Figure 70p
A flat wide brush is drawn across the zig-zagging to produce the blending of the tones. Top lights are then added and brushed into the average.

Figure 70q ➝
The finished portrait . Additional refinements of color, value, drawing, correcting and softening edges are added. Heavier paint is applied to the light areas. When you feel you are finished spray the entire painting with a thin coat of Damar Retouch Varnish and put in a dust-free place to dry.

I do not wish to give the impression that everything you paint can be reduced to an exact numerical order. There are too many variables that effect the procedure, besides it can eliminate much of the fun and enjoyment you should get from painting. What I wish to convey is the idea that you need both a way of thinking and a way of doing. This coupled with long hours of practice, produces skill. It is called "Craft". When you are a competent craftsman and make use of your feelings and imagination — we'll call you an artist.

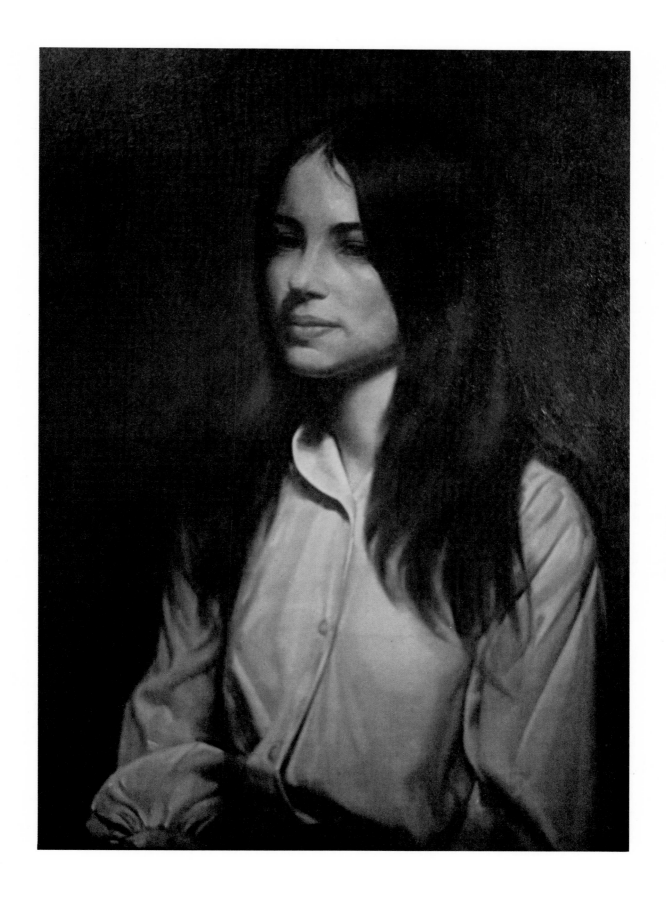

CHAPTER 19
Explanation of Some Art Terms

The art world, much like the world of music or any profession has a great number of terms that are bandied about and little understood. The purpose in their use seems to be to create an air of mystery and ambiguity. Many authors of art related articles and books are guilty of this humbug. I would like to clear up some of this mysticism as as a contribution to sanity of the practicing painter. Here are some straightforward comments about a few art terms that are commonly misused and misunderstood.

Impasto It simply means a brush stroke that is heavily loaded with paint. Artists long ago found out that shadows have the appearance of thinness whereas the lights have the appearance of thickness. By exaggerating this principle the artist can obtain a feeling of light falling upon the subject. Rembrandt and Rubens worked with impasto most effectively. The solid, thick stroke of paint projecting from the canvas catches the light and gives the impression of relief. Impasto also serves the purpose of varying the surface quality of the painting.

It is good painting technique to keep the shadows thin and simple whereas in the areas of lightest light your brushwork should become crisper. The paint itself should be heavier and contain more broken color. The impastos should be made with stiff paint, that is, paint that is devoid of most of its oil. They are best applied with a bristle brush.

Velatura Literally it is a veil. For example, if a shadow appears to be too warm a velatura can be applied to cool it.

The velatura is usually made with white paint that is highly diluted with oil or oil and turpentine. (A richer medium could be used if the artist is working for a richer surface.) The white paint may contain a tint of another hue if necessary, or you can use any pure color you need for the purpose. It is applied thinly and evenly over the shadow area and may overlap the halftone. It *should not* be too obvious to the eye or it will appear as a gross error. This veil is used to give the appearance of air and depth within the shadow area and keeps all the tones in proper balance.

There are times when the halftone area needs this treatment; or, even at times, when the entire face or torso or drapery requires it.

The velatura should be applied only over thoroughly dried paint. The area to receive it should be first rubbed with oil, this allows the velatura to meld with the layer beneath it. Varnish, in this case is not advisable as it might destroy the delicate balance of the hues. It is better to have two thin veils or velaturas than one thick obvious one.

Scumble It is somewhat like a velatura. Think of a scumble as a scrubbing effect and a velatura as a caressing effect. The scumble is put on more opaquely and obviously than a velatura. Usually scumbling is done with a stiff bristle brush. It can be white or any color. Use it to break up a flat, dull looking area; to create atmospheric effects; to soften edges and sometimes to model forms. The paint is applied over another completely dried layer of paint with very little medium or at times completely dry. It is not necessary to have an isolating coat of varnish between the layers.

Common uses of the scumble are effects such as a smoky area over skies, dust covering objects, atmospheric mists, water splashing over rocks, or over ships and other similar effects. Put your paint on in the way it occurs in nature.

The paint that is scumbled on must not be allowed to dry faster than the layer of paint beneath it or else it will crack.

Glazing This term has a awe inspiring and magical effect on many students. Usually the first question a novice asks when he starts painting is, "How do you glaze"? It's as if the knowledge of glazing would enable him to paint like a master.

Glazing was used and is used by artists only when a particular effect cannot be abtained by any other method. A good painter never glazes unless he has to.

Painters of the past had a limited number of colors with which to work, and they resorted to everything in their means to obtain the maximum amounts of hues and chromas from their palettes. They intermixed colors and glazed one color over another. For instance, if an artist wanted to paint a violet color that wasn't available, he would have to make it by superimposing one transparent color over another, in this case a red-purple lake over a blue ultramarine. The glazing of one color

over another produces an entirely different hue, as well as increasing the brilliance of that hue. In glazing, there is danger of cracking and yellowing, as well as, losing the value, texture, and character of the subject. Of course, glazing should be done only over dry paint.

A legitimate use of the glaze is to obtain a stronger chroma at a light value. In the previous chapters you have seen how white added to a color brings it up to a very light value and loses chroma. In some cases this is desirable and in others it is not.

Suppose you are painting a silky or satiny red-purple drapery. The body colors are easily obtainable, but when you come to the ridge of the material where the lights jump up in value there is a great loss of chroma because of the admixture of white. It is these light areas that would have to be glazed with, say, Alizarin Crimson to increase their chroma and unify them with the rest of the color tones without losing the values to too great a degree.

In another case there might be an entire piece of drapery of a hue you cannot obtain when you have its value. In this instance you will have to underpaint the drapery in monochrome making it lighter in value than it appears and, when dry, glaze it with the desired hue. The glazing should bring down the value to its proper level. The highest lights can always be restated and glazed over again until the desired effect is obtained. Deep, rich glazes can also be used over the darker areas to prevent these areas from looking dull.

A third use would be to unify a painting that doesn't quite "hang together". This is done by spreading the glaze over the entire surface. This unifies the picture much as a colored varnish would. In fact, the colored varnish is a glaze.

A fourth use would be in an all glazing technique. Here one would use thin layers of paint, one over the other, working with the lightest tones first and later darkening them where needed, or altering the hue, with succeeding glazes. In this technique you would have to start with a pure white surface that is non-absorbant.

In all cases the underlying paint layer must be thoroughly dry. In most cases there must be a clear thin coat of varnish isolating the underlayer. This is not to be glazed over or painted upon until dry.

In some sunsets in landscape painting, the entire surface of the canvas is first scrubbed with a thin coat of oil. The glaze is applied and then worked into and fused with a layer of oil. In this manner a subtle gradation of tones is accomplished. In the future there will be an evenness of yellowing and aging.

If the glaze is to cover a small area then merely dilute your color with oil or your favorite medium and apply it thinly. However if you are to cover a large area then you will find it easier to make a mixture of oil or oil and varnish in a palette cup. Stir your desired color or tint into the liquid until it is thoroughly dissolved and then apply it with a brush, a cloth, or a sponge.

A glaze should never be obvious. Better ten thin glazes than one thick glaze.

An obvious glaze is one of the crudest and cheapest looking effects an artist can achieve.

Certain colors are better suited for glazing than others. Transparent colors such as Alizarin Crimson, Rose Madder, Terre Verte and Van Dyke Brown are fine for glazing.

You can test a color for glazing suitability by diluting a small amount of the desired color with oil then with a brush or finger spread it on a piece of plate glass. If it appears to be the color, transparency and luminosity you want, then use it. If it is too opaque or the wrong hue, don't use it. Some manufacturers state the opacity or transparency of a color on the tube; others publish a booklet describing the chemical contents and qualities of their colors.

Postscript

In the final analysis, what is great in art is craftsmanship and the amount of feeling the artist conveys through his work. The craftsmanship can be acquired with a vast amount of practice and application of sound technical principles. The feeling comes from deep within the artist's psyche supported by the application of knowledge. In this book I have tried to give you the technical knowledge essential to the painting of representational pictures with oil paints. Much of this information is applicable, as well, to other styles of painting and the use of some other opaque mediums. I have also sought to encourage you to use your feeling faculties; to learn how to "see" rather than to look, and to develop a way of thinking that will guide you throughout your life.

A work of art can be many things, a painting, a sculpture, an edifice, a sonata, a symphony, a poem — even a way of life. One of the most difficult things in the world to do is to start a work of art. It is just as difficult to finish one.

A long time ago, when I was a student in Mr. Reilly's class I asked him the question: "How do I know when I am finished." "If you are a true artist," he replied, "you will never consider your work finished for you will always feel that you could have done it a little better, or executed a certain passage in a nicer way. Do the best you can, turn in your work and resolve to do better on the next one."

I now turn in my work!

Bibliography

Boltz, Valentin. Farbuch oder Illuminierbuch. Basel: 1549.

Corneille, J.B. Elemens de la peinture pratique. Paris: 1683.

Eastlake, Sir Charles Lock. Methods and Materials of Painting of the Great Schools and Masters. Dover Publications Inc: 1960

Harris, Moses. The Natural System of Colors. London: 1766 (?).

Hogarth, William. The Analysis of Beauty. London: 1753.

Munsell, Albert Henry. Atlas of The Color System. 1910.

Schmid, F. The Practice of Painting. Faber & Faber Ltd. London: 1948.

All drawings, charts and paintings in this book were done by the author with the exception of those identified by other sources.